LATIN AMERICAN DRAWINGS TO

NC102 .S76 1991

P9-BJR-690

LATIN AMERICAN

DRAWINGS

Today

Latin American Drawings Today

is organized by the San Diego Museum of Art.

This project is funded by the California Arts Council and the

Latin American Arts Committee of the San Diego Museum of Art.

Any findings, opinions, or conclusions contained therein

are not necessarily those of the California Arts Council.

March 16 - April 28, 1991

Design: Miriello Grafico

Editing: Mary Stofflet

Typography: Dean Amstutz, Miriello Grafico/Macintosh IIcx

Separations and Lithography: Frye & Smith

Bindery: Roswell Bookbinding

Photography: Philipp Scholz Rittermann

Photo Credits: Erik Landesberg, The Forbes Magazine Collection,

New York (Bravo), Courtesy of Nohra Haime Gallery (Tacla)

Publication production coordinated by

David Hewitt, Head of Publications and Sales,

San Diego Museum of Art

Library of Congress catalog card number 91-60076

ISBN 0-295-97107-X

© 1991 San Diego Museum of Art

CONTENTS

LATIN AMERICAN

DRAWINGS

Today

MARY STOFFLET

Curator, Modern Art

•

WITH ESSAYS BY

SHIFRA M. GOLDMAN
Research Associate, Latin American Center, University of California, Los Angeles

GLORIA ZEA
Director, Museo de Arte Moderno de Bogota

BÉLGICA RODRÍGUEZ
Director, Museum of Modern Art of Latin America, Washington, D.C.

Distributed by the University of Washington Press, Seattle and London

Riverside Community College
Library
4800 Magnolia Avenue
Riverside, California 92506

ACKNOWLEDGMENTS

Latin American Drawings Today

Latin American Drawings Today was developed with the cooperation and assistance of many individuals and institutions. The artists, first and foremost, are to be thanked for their generous loans and diligent efforts to comply with the logistical details of organizing an exhibition of this scope.

Staff persons who have devoted countless hours to make this project a success include Mary Stofflet, Curator, Modern Art; Louis Goldich, Registrar; David Hewitt, Head of Publications and Sales; Mitchell Gaul, Head of Design and Installation; Anne Streicher, Assistant Registrar; Dan Ratcliff, Assistant Registrar, Claire Eike, Librarian; Barney Malesky, Curator of Education; Ellen Willenbecher, Education Coordinator, Gluck Program; Mardi Snow; Public Relations Coordinator; and Linda Stephens, Corporate and Government Relations Coordinator.

For his early participation and advice we wish to thank Jose Tasende, and for their suggestions of artists and continued involvement we wish to thank the exhibition's advisors: Marc Berkowitz (d. 1989), critic, Rio de Janeiro; Jorge Glusberg, director, Centro de Arte y Communicacion (CAYC), Buenos Aires; Bélgica Rodríguez, director, Museum of Modern Art of Latin America, Washington, D.C.; Rafael Squirru, critic, Buenos Aires; and Gloria Zea, director, Museo de Arte Moderno de Bogotá.

We also wish to thank the lenders to the exhibition: CDS Gallery, New York; Bonino Gallery, New York; Galerie Albert Loeb, Paris; Odon Wagner Gallery, Toronto; Galería de Arte Ruth Bencazar, Buenos Aires; Virginia Miller Gallery, Coral Gables, Florida; Ricardo Orozco; Adam J. Merims, Los Angeles; Carin Arte, Vicenza, Italy; Gilberto Chateaubriand; The Forbes Magazine Collection, New York; Galería Carmen Cuenca, Tijuana; Nohra Haime Gallery, New York; and Marion E. Greene, St. Helena, California.

We are delighted to have the participation of Shifra Goldman, who prepared the principal essay for the exhibition catalogue. Translations from the Spanish were provided by Rebecca Ann Cabo, and translations from the Portuguese by Jose Alves.

For their work on the catalogue we wish to thank Ron Miriello and Michelle Barbesino of Miriello Grafico, Philipp Scholz Rittermann, photographer, and Judy Champ of Frye & Smith.

The exhibition has been funded by the California Arts Council and the Latin American Arts Committee of the San Diego Museum of Art, for which we are most grateful.

STEVEN L. BREZZO *Director, San Diego Museum of Art*

INTRODUCTION

Latin American Drawings Today

Drawing, in the closing decades of the twentieth century, is a complete and independent art form. Emerging from a non-contiguous history of works made in preparation, as quick observation, for presentation, or as studies, drawing at last stands alone as a vibrant, spontaneous, self-contained, and very contemporary medium. While drawing as a form of human activity can be as simple as a circle or an arrow inscribed with a finger in the sand, we often think of the art of drawing as dating to the Lascaux cave images, or, in this hemisphere, to pre-Columbian murals. Fragile drawings on paper survive from the European Renaissance, often in the form of sketchbooks or preparatory drawings for paintings or murals. The methods and materials are constant, and reappear until the present time: charcoal, graphite, ink, pastel, and watercolor. Acrylic, collage or assemblage, and mixed media appear occasionally today but, on the whole, traditional drawing materials are as appropriate for the creation of contemporary drawings as they were for the sketches of Leonardo or Michelangelo.

The fragmentary history of drawing in combination with the complex political development of Latin America would seem to create an unmanageable focus for an exhibition, and yet a unifying factor emerges: an extraordinary vitality. The twinned threads of pre-Columbian murals and European Renaissance painting have coevolved centuries later into a strong tradition of fusion plus exploration. Folk art, mythology, and an ever-fluctuating interaction with international post-war art influences contribute to Latin American drawing today. One senses through these drawings not a shared sensibility, nor even a shared past, but a common vibration blending the influences and verging on breakthrough, as though some milestone in the visual arts is at last within reach.

Style, content, and intention are varied in these drawings. Humberto Aquino describes himself as "a tonal painter. In my works, tone counts above local or variegated color. Tone produces one dominant continuous effect; its presence in the pictorial surface establishes the unity that is capital to a work of art." Regina Vater, whose drawings are plans for future installations, writes: "Since the seventies, and particularly in the drawings selected for this show, I [am] pointing out ecological issues in my art." Antônio Henrique Amaral describes his drawings as "exercises in establishing intimate links between my feelings, daydreams, thoughts, and my hands, my eyes, and the materials used." Alvaro Barrios tries "to create illusions in a world where time and space occur in an unknown dimension. A dimension where art history, sacred history, and science fiction are united without contradictions in the silence and logic and dreams." Of her very personal vision, Lucía Maya writes: "My obsession for detail and reinventing the pleats of materials, the hair, the heart and the plants, is due to a particular interest in that all the elements that shape my pictures are provided by the same expressive charge."

What has all this to do with Latin America? Perhaps nothing. Yet those who insist on connective tissue will be encouraged by the words of Oswaldo Vigas, written in 1967: "... Latin America is a land loaded with mysterious signs and obscure portents. Telluric symbols, magic and exorcism are the deep components of our condition. At the same time that they reveal our essential nature, those symbols place us and involve us in a world of disturbing ferment..." The work seen in *Latin American Drawings Today* points the way toward new forms that are, like twentieth century drawing, immediate, spontaneous, and independent.

During the planning of this exhibition, the following people have generously provided encouragement and information without which *Latin American Drawings Today* in its final form would be unthinkable. We are extemely grateful to Tancredo de Araujo, Marc Berkowitz (d. 1989), Judith Bettelheim, Fernanda Bonino, Antonio Cabero, Elsa Cameron, Luis Cancel, Carmen Cuenca, Kirk de Gooyer, Marina Drummer, Ignacio Galbis, Shifra Goldman, Llilian Llanes, Carmen Melian, Philip Orenstein, Mari Carmen Ramirez, Rafael Squirru, Clara Sujo, Jose Tasende, and Phillip Verre.

M A R Y S T O F F L E T *Curator, Modern Art*

(RE)MARKING THE LINE:

The Hidden Landscapes of Latin America

We are entering...the era of Latin America, foremost world producer of creative imagination - the richest and most necessary basic material of the New World. The great premonition of a still undiscovered continent is that death has been defeated by happiness; that there will forever be more peace, more time and better health, more hot food, more delicious rumbas, more of everything good for everyone. In other words: more love.

Gabriel García Márquez

———

In surveying the drawings of almost fifty artists from twelve countries located in North, Central, and South America and the Caribbean—Argentina, Brazil, Chile, Colombia, Costa Rica, Cuba, Guatemala, Mexico, Peru, Puerto Rico, Venezuela and Uruguay— one is struck by the great variety in style, syntax, size, medium and technique; in implicit or explicit content; and even in the "race," nationality, and gender of their makers. Contrary to the fantasies of North Americans and Europeans, Latin American artists are not exotic persons who live in "pristine" environments and translate an alleged primitivism into predictable patterns of color and form. They are citizens of the world, aware of modern politics, economics, philosophies and cultural experiments—to which many have contributed, often without adequate recognition from the hegemonic masters of these

discourses. Regardless of where they live, nonetheless, their strength is that by and large they have chosen not to become so "universal" as to be homogenized; while drawing freely on the international bank of ideas and images, they fuse these ideas and images with those of their personal and national concerns. Indeed, the absolute hegemony of style, formalism as an end in itself, and the linear history of art based on the ideology of vanguardism and the master narrative of European-U.S. domination, receives short shrift in Latin America, as did the former ban on "literary content" propounded by critics from Clive Bell to Clement Greenberg. The absolute autonomy of art as an independent enterprise divorced from social praxis has not been an acceptable stance in Latin America. The syntactics of form, therefore, are not separated from its semantics; form and meaning are irrevocably wedded.

PRECURSORS

Considering that a new generation of artists emerges approximately every ten years, three artists in the present exhibition, **Enrique Grau** of Colombia (1920), **Oswaldo Vigas** of Venezuela (1926), and **Helen Escobedo** of Mexico (1928), constitute not only the oldest generation, but display three very different approaches to style, concept and drawing methods. Grau has always been a figurative artist–a dominant mode in his country. Over the years, Grau has refined his style. Against a plain or patterned background, one or several fleshy, voluptuous Rubenesque figures, female or male, with oversize hands and feet, dressed or semi-dressed, are richly attired in old-fashioned garments or under-clothing rendered in great detail. A magic or mysterious feeling inhabits these works.

By contrast, Vigas took a route in which he consistently opposed the kinetic/optical direction synonymous with Venezuela's best-known artists. His mature work focuses on a semi-abstract geometricism with strong outlines that, nevertheless, retains an emotional charge, a suggestion of natural forms, and symbolic or mythical presences. Spotted jaguars, strange birds, skulls, masks, and humans are synthesized in an original postcubist way.

Escobedo, within the context of abstract and monumental sculpture advanced by Mathias Goeritz in Mexico of the 1950s, is known as an experimental and architectonic sculptor and environmentalist. Embracing both the organic and geometric,

her past work has had reference to pre-Columbian and contemporary forms, and to industrial and natural materials. Recent constructions of plants, gardens and landscapes make use of different grades of painted wire. To combine, therefore, wire as ground and frame for the realistic drawings of ocean waves and surfaces is wholly within character.

REALISMS

A subdivision of representational art, realism has been defined as "a painted or drawn surface that is seamless, without cubist sectioning or internal jumps and cuts: the visual image unifies the surface completely, from edge to edge."[1] In contemporary Latin American art, this kind of realism can range from fully-developed academic rendering, through photo-assisted realism, to the transitory effects of photorealism. **Claudio Bravo, Fernando Allievi, Humberto Aquino, Ever Astudillo, Liliana Porter, Francisco de la Puente,** and **Rafael Hastings** fall into one or another of these categories. The peak of Chilean academic realism has been achieved by Bravo who astonishes with the sheer articulation of his technical facture which is as close to photography as an artist can get without utilizing the distinctive distortions of the one-eyed camera lens. His compositions of single figures, isolated against a plain ground, are stable, balanced, fixed, and frozen in space with classic equilibrium. A modern note persists in the casual posture, the positioning of the figure in space, and a distinctly homoerotic suggestiveness.

While Allievi invokes ancient civilizations with his carefully finished subtly-toned interiors and the fusion of Egyptian and Greek sciences at Misram (Alexandria) with shadows of classical architecture, Aquino's small scale drawings are so fine-lined and elaborately finished with acrylic glaze that the division between drawing and painting is hard to distinguish. The ironic even humorous mixture of Greek sculptures, Renaissance costume (on what one suspects is a portrait of the artist himself), and modern references might be a comment on the history of art, or the history of his own artistic sources.

Astudillo's urbanscapes of cut-out photo-assisted silhouetted figures collaged on the surface are reduced to tonalities and limited color. The young men on the streets of lower-class neighborhoods (or in mythic settings), in undershirts or bare-chested in the uncertain light of dawn or dusk, suggest alienation.[2]

Porter and de la Puente play with illusions of realism. Porter's drawings evidence three layers of existence: that of the artist's sketch which, like all art, is an obvious artificiality; that of photographically-rendered but two-dimensional objects; and that of real objects montaged on the surface. All have cast shadows, but the artist defies us to instantly know or finally remember what is real and what is illusion. De la Puente creates a flat informalist painting and contrasts it with objects rendered in *trompe-l'oeil*, which cast believable, yet fictional, shadows. Hastings' two drawings are standard sketches rendered to a finished state, or fragments and details apparently taken from life.

Within the category of expressive realism are the drawings of **Luis Caballero** and **Antonio Martorell**. Focusing on the human figure, Caballero has successively experimented with the anguished forms of Francis Bacon and the gigantism of Michelangelo's. "The nude," says the artist, "must be painted sensually, erotically, lovingly. With semen and not with turpentine." His drawings of fragmented homoerotic male nudes in the most varied positions are charged with energy and emotion. Martorell's trees, as scarred stumps or flourishing tropical foliage, are testimonies of the ravages exacted from his native Puerto Rico by hurricanes and human agencies, and to the possibility, nevertheless, of exuberant survival. To the artist, tree-derived charcoal seemed the most appropriate medium.

Finally, despite the caution mentioned by Alloway, the two photographically-derived drawings by **José Castro Leñero** are included though they fragment and partition their segments of reality abstracted from the urban landscape of Mexico City.

THE SOCIAL AND THE CRITICAL

A multiplicity of styles and references are invoked in this category. **Arnold Belkin** sanctifies Lucio Cabañas, an unofficial guerrilla folk-hero assassinated by the Mexican army in 1969, by associating him with the revered revolutionary figure of Emiliano Zapata. His ground is amate paper, made by Otomí Indians according to ancient methods. **Herman Braun-Vega** makes a related political statement with a Peruvian peasant sowing seeds of "solidaridad/NOSE" (solidarity: North-West-South-East in Spanish) which are indicated as the cardinal compass points. **Jorge Alvaro**, touching the edge of Grosz-like caricature,

13

evokes shock by his erotic yet decadent contortionist performing to the bald, solidly planted, military men and government types with dark glasses reminiscent of the recent Argentine dictatorship and its cohorts. **Beatriz González** of Colombia, in a more Pop style, lampoons the same targets chosen by many Latin American novelists: the pompous, self-important presidents and their sycophants. *Palaciegos* collapses two Spanish words into one: "palace" (where presidents reign), and "the blind men." Two Central America artists, **José Miguel Rojas** (Costa Rica) and **Isabel Ruiz** (Guatemala) turn to neofigurative expressionism for their critical reflections on the U.S.-supported holocaust in their region. Rojas draws on German expressionist prototypes for his sheep-like and deadly "man in the street" portrayals, expressing an existential despair that change can occur with such types. Ruiz lives within a dictatorial state that has tortured, killed and exiled thousands of Maya Indians. Drawing on Indian cleansing rituals, she evokes images of death and human suffering in a style which metamorphosizes fears into fragments of monstrous animals. Truly does she name one of her series, *Besieged History*.

Four Chileans, **Guillermo Nuñez**, **Patricia Israel**, **Jorge Tacla**, and **Guillermo Bert**—the former two barely returned from long political exiles during the recently-deposed Pinochet dictatorship; the other two living in the United States—project their critical anguish in different expressionist ways. Jailed for many months in Chile, Nuñez reflects on his personalized response to exile by meditating on Manet's *Luncheon on the Grass*, and on Boësse, a village near Paris where he lived. For Nuñez, all of France is "other," it is the place of exile where none can hear the internal scream of his remembered terror. Israel has made the "discovery" of America a central theme of her series, *América de Cuerpo Pintada* (America of the Painted Body): for her, the series is not an homage to the Columbian quincentenary, but to the American aborigines. Rather than an encounter, she says, it was an devastating invasion, using evangelization as its argument, and gold as its goal. Like other Latin Americans, Israel sees history as an aid to memory, as a key to understanding the present. Tacla's works invoke the almost-extinct Indians of Chile in terms of their archeological and biological remains: pottery, tools, mythologies, topography, and foods. He links them with the Africa so close to his emotional roots, and thereby with all the oppressed, dispossessed, and disenfranchised. Bert, by contrast,

focuses on the alienation and corruption of urban North America, invoking a vocabulary of colonial Catholicism: the empty but crucified shirt; the headless embrace of greed.

WITH PLAY, HUMOR, AND IRONY

A Brazilian critic has recorded that **Antônio Enrique Amaral's** drawings are "graphic registrations of the unconscious."[3] Certainly his small sketches are spontaneous, rich and joyful in color, highly erotic, and playful. Even the landscape, suggested by Rio's beaches and incredible pointed mountains, is a record of sexual desire. The erotic motif continues with **Carlos Zerpa's** Pop psychedelically-colored pun on the similarities between cigarette lighters and phalluses. Zerpa, trained in design, photography, and printmaking, does paintings, drawings, sculptures, cartoons, performances, assemblages and installations, creating what has been called "a microcosmos zerpiano."

15

Luis Benedit, a practicing architect, has moved his attention from conceptual installations concerning the biosphere to the rendering of his son's toys and games as whimsical drawings, in which drafting techniques can be noted, for small full-color Pop sculptures. **Félix Angel** has long specialized in sports figures expressed so as to suggest great power. Thus the muscular torso of his bicyclist dominates the flimsy bicycle, while a powerful and ponderous horse, like an enormous steam locomotive, dwarfs the tiny jockey. The work of **Alvaro Barrios** offers constant surprises. His present drawings draw on Greek subject matter, mixed with contemporary references, as they might appear in a comic book, or in kitsch illustrations for mass publications. Their "Star Trek" qualities place them squarely within postmodernism.

MAGICAL, MYTHICAL, TELLURIC, ONEIRIC AND SURREAL

Departing from his well-known renditions in drawing, painting and printmaking, of the human eye, **Rodolfo Abularach** employs all the subtle tonal nuances of which he is a master to create broad planes and the simplified forms of human beings that appear to have erupted from the earth itself. The artist uses fine parallel and crosshatched lines for one group, and scribbled searching lines for the other. **Manuel Mendive** is both a practitioner of Afro-Cuban *santería* in Havana, and a trained artist who translates its myths and rituals into inventive drawings and paintings in a deliberately primitivizing style. His images are not total inventions: each drawing renders a particular story from the Yoruba-

derived but hybridized Cuban religious beliefs. Changó, Ogun, Eleguá, Obá, Ochún, Ikú, are male and female deities from Nigeria and Dahomey who act out their dramas in his work. **Francisco Toledo**, from Oaxaca, Mexico, functions similarly. Widely traveled, and (like Mendive) with a large knowledge of art history, Toledo's originality lies in translating the orally-transmitted Indian legends and fables of his region into sophisticated Klee-like drawings and paintings without losing any of their freshness. Animistic and phallo-erotic presences abound with the fish, birds, insects, reptiles, animals, humans—along with contemporary objects such as sewing machines—that proliferate in his magic world.

With the drawings of **Jorge Damiani**, we enter the realm of the oneiric and surreal. Damiani, "after a classical, rational, pigeonholing period...has moved into an existential, informal, anguish-laden language."[4] Metamorphosis, eroticism and the incongruous space of dreams are made palpable. The human exterior and interior are simultaneously visible—a characteristic of 1960's neofiguration. Strange creatures and objects emerge from structural voids in his work which echo the sculpture and drawings of his Uruguayan compatriot, Gonzalo Fonseca. **Ramón Alejandro's** semi-abstractions also suggest surreal and erotic—but Baroque—worlds, with Cuban tropical fruit and lush vegetation. Menace and imprisonment threaten the vulnerable open fruit in the form of iron teeth, prison-like boxes, spikes and thorns. **Elba Damast's** semi-abstract drawings assault one with impetuous psychic energy and a tangible physicality which seems to spring from the surfaces. Customarily she combines paint with assemblage which violates all flat surfaces; or creates marvelous constructed houses from painted wire, both of which appear as parts of her male/female drawings. By contrast, **Silvia Rivas** engages the space of her drawing as a field upon which purified geometric fragments float and are amalgamated through their contiguity, or through gestural strokes. A landscape with fencing mimics collage. The infinity of the landscape discourses with that of the drawing surface.

THE FEMALE VOICE

Increasingly, in the late 1970s, women in greater numbers than ever before became visible in the Latin American artistic arena, as elsewhere. A traceable current across Latin America is the one probing the interior world of women's sensibility. Women artists are treading on the borders of prohibited revelations, given leave by the feminist movement

(whether or not they subscribe to its program) and by the powerful example of women who preceded them, particularly Frida Kahlo. Kahlo is certainly part of the incantations of Mexico's **Lucía Maya**–whose delicacy of drawing, decorative embellishment and iconic invention seem to evoke the pre-Raphaelites and Symbolists of the last century and the Surrealists of this one–and is suffused with the longings of amorous poetry. Her work is filled, she says, with "abysses, enigmas and perversions," whose spine is provided by a striking sense of contour and design. The more realistic watercolors of **Alicia Carletti** focus completely on the Freudian ambiguities, fantasies, and what she calls the "malignant games" played by little girls as they dream–in gardens of giant plants–of being adults.

 Norma Bessouet's *pelonas* (bald women) date from her move to New York in 1981. The exquisitely drawn pelonas, infused with loneliness, melancholy, and hidden sexual desires, are reaching for love. According to the artist, the women of her drawings and paintings are not nudes, but very sensitive and vulnerable women who are psychically and physically naked–an important distinction since nudity, iconographically, is an accepted "garment of skin" which objectifies the female, while nakedness is vulnerable *because* it is subjective. With the most delicate obliqueness, **Haydée Landing** compares the urban chaos of forgotten cities with the flux and birthing of the tropical forest; nevertheless, these are interior hidden landscapes emanating from the dreams of the artist, and the fragile women who inhabit their spaces.

THE IDEA AS OBJECT

Preliminary to the fashioning of installations of a conceptual nature, comes the sketch in which ideas are visualized and refined for future projects. For **Regina Vater**, ecological and human destruction are the material for social and metaphysical statements about life. The use of Amazonian and Yoruba mythology, she says, originates in her own bio-system. The great snake and logged tree juxtapose television technology; wooden boxes symbolize the trains or ships that carry off Brazil's natural resources to the industrialized countries. **Rimer Cardillo**, a master printmaker in the Uruguayan tradition, uses the box as a confining vehicle for memory. Translated into large-scale constructions, his boxes and frames become memorial altars, triptychs, reliquaries, memorializing the lost forests of the Amazon, and the tortured, dead and exiled of the recent Uruguayan dictatorship.

In conclusion we can say that the formerly second-class(ed) genre of drawing, now recognized as a major art form, is an appropriate vehicle to transport the hidden landscapes of Latin America to our northern vision. The skill, originality, variety, complexity, joyousness and grief, profundity, and human aspiration are self-evident.

———

18

SHIFRA M. GOLDMAN

Research Associate, Latin American Center, University of California, Los Angeles

NOTES

[1] Lawrence Alloway, *Realism and Latin American Paintings*, The Center for Inter-American Relations, 1980, p. 7.

[2] The title *Ho-Ménage à Trois II* plays on the Spanish word "homenaje" (homage) and the French term for a three-way sexual arrangement.

[3] Frederico Morais, *Caminhos de ontem: 1957/1982; Trabalho de hoje:1982/1983*, Galeria Alberto Bonfiglioli, São Paulo, 1983.

[4] Angel Kalenberg, "Jorge Damiani: The Being Within the Being," *XX Bienal de San Pablo, 1989*, n.p.

Latin American Drawings Today

Drawing has been a medium in which Colombian artists have excelled, expecially since the 1960s when many painters started a perhaps unconscious movement in favor of its independence as an artistic category. Previous to the sixties it is hard to find an entire body of work dedicated exclusively to exploiting the power of line, material, and paper. Drawing was used by Colombian artists mainly as an excuse for grander ventures in easel and mural painting, and only the beautiful and fine nudes of Ignacio Gómez Jaramillo (1910-1971), inspired by those of Picasso, may account as completely "free" drawings during the first half of the century. Curiously enough, no serious drawing is known by Alejandro Obregon, Colombia's first and most important modernist painter up to the 1960s.

It is precisely an artist of Obregon's generation who begins to think of drawing as a truly independent medium. Enrique Grau (b. 1920) introduces in Colombian art the idea of the drawing series, with his Visions of St. Anthony, 1966, which emphasized the capacity of line and ink to tell a story with almost no reference to centrifugal perspective and chromatic atmosphere, a lesson continued by, for example, Beatriz González (b. 1937) in the early 1980s and Lorenzo Jaramillo (b. 1955) in the last five years. During the early sixties, Fernando Botero (b. 1937) made a brilliant group of charcoals on paper and canvas with subjects like portraits and still lifes. To this period belong also the energetic and politically engaged ink and pencil works of Pedro A. Herrán (b. 1940), and the fanciful mixed media collages, based on comics and kitsch, of the gifted Alvaro Barrios (b. 1945).

In the beginning of the 1970s, Colombia witnessed the appearance of a great number not only of draftsmen but of graphic artists as well. Of course, many of them worked in both media, usually not making a clear distinction between the two, as in the case of Herrán. However, the presence of a strong graphic movement gave a definitive new outlook to draftsmen like Luis Caballero (b. 1943), Darío Morales (1944-1989), Miguel A. Rojas (b. 1946), and Ever Astudillo (b. 1948), all of them interested in rescuing the human figure as a design device and aesthetic base. Caballero, going against all avant garde postures, stubbornly used ink and charcoal to produce brilliant and pseudo-academic homoerotic drawings while Morales followed course but with the female nude. On the other hand, Rojas mixed hyperrealism and conceptualism to deliver what might be considered the most advanced, both technically and ideologically, opus of Colombian drawing up to the end of the eighties. His first works combined homoerotic images (in pencil and graphite) with installations to render a world common and morbid at the same time. His big ephemeral drawing, titled Grain, 1980, made use of tinted, dried earth to reproduce a "room" which derived from childhood recollections and offered to the public an inaccesible, literally, "popular ambience," since the installation consisted of the exact reproduction of a typical Colombian tile floor, hermetically sealed with a glass door.

The 1980s saw the emergence of a young group of artists who kept the tradition of drawing as a free enterprise and who introduce a much needed new and sophisticated ideography. Though still developing, the drawings of Lorenzo Jaramillo, Victor Laignelet, José Antonio Suárez, all born in

1955, and Luis Luna (b. 1958) make a sharp distinction between painting and what is done with line and paper. They are, maybe not so surprisingly, inclined to eliminate pictorial effects and to work in series, as did Grau and still does González. But they see their subject matter as a means to expand a very private but, at the same time, cosmopolitan fiction. Jaramillo's huge series of nude male models, cool but expressionistic; Laignelet's cold and metaphysical bullfighting scenes; Suárez's tiny, in format, and cryptic travel diaries; and Luna's flat and symbolistic blue pictograms, have all injected into Colombian drawing a definitive postmodern essence, through which one may see, subtly, the nervousness and fear of recent Colombian cultural and political life.

• Of course, this last group is signaled because of its newness and high quality. But the artists mentioned above, as well as many others who did not have a significant drawing "presence," have continued their work in the medium, sometimes going over the border of what could be called "straight" drawing. Barrios and Rojas have added collage and photography to their work; González relies now heavily on pastel; and Caballero has increased his homoerotic charge. Older artists, not usually known as draftsmen, have produced interesting and provocative work, like Santiago

Cárdenas (b. 1937), who deliberately appropriates Matisse's aesthetic, and Ana Mercedes Hoyos (b. 1942), preoccupied with introducing purity of line and themes through her still lifes.

• Thus, with all the examples mentioned above, it is easy to observe that contemporary Colombian artists have understood the aesthetic and expressive possibilities of drawing as an independent medium, and that they offer many of the variants which make drawing a very actual alternative.

21

GLORIA ZEA
Director, Museo de Arte Moderno de Bogotá

DRAWING IN VENEZUELA:

A New History

The history of contemporary drawing in Venezuela started in the 1970s, in connection with a cultural institution, The Foundation of Arts and Culture (FUNDARTE). In this period the Foundation was part of the government of the Federal District. This history began with a marked interest in this artistic medium becoming self-sufficient in order to consider its production as valid works of art. The National Drawing Biennials that the Foundation began complemented activity that was being renewed in the Venezuelan fine arts.

• Drawing has always existed in Venezuela, yet very few drawings remain by prominent artists, such as Cristóbal Rojas, Arturo Michelena, Antonio Herrera Toro, and Martín Tovar y Tovar. However, there is an artist to remember, Cármelo Fernández. Upon his return to Venezuela in the middle of the nineteenth century after study in Europe, he began a professional career. For

political reasons he had to exile to Colombia. There he was invited by the scientist Agustín Codazzi to work in the famous Comisíon Corográfica de Colombia in 1849. His experience as an illustrator of landscapes, plant life, and Colombian and Venezuelan popular customs enabled him to leave a good many drawings for the history of art in Venezuela. Another fundamental figure is Armando Reverón. With his peculiar energetic style of line, saturated with force and emphasis, Reverón produced important works on paper that became a foundation for contemporary drawing in the seventies. The works of Reverón are not only significant for technique but also for theme. In Venezuelan drawing during the seventies these influences appear in many versions. Above all it will be notable that an extreme expressionistic trait was dominant during the whole decade, and that it persists today.

• Little by little, as the twentieth century advanced, drawing began to take a prevailing position in the interest of the artists. But painting continued to be preeminent and drawing continued to be considered as a minor medium during almost all the first half of the century. In the Fine Arts Academy, drawing was a practice to master the skill of painting. The drawings continued to be sketches for the paintings, as had traditionally been done. However, today one can count important works that shape the limited tradition of drawing in the country. The seventies constituted a moment of challenge in the Venezuelan fine arts. It was a time of profound creation as well as of reflection on the artistic local problems. This way drawing stood out as a "modest" medium in comparison with the megalomanic form that painting had taken on (large formats, epic themes, quasi-grand nature). A good number of young artists turned their interests towards drawing as their only way of artistic expression, that is to say they became artist-draftsmen (artistas-dibujantes). The "modesty" of drawing led them to take more intimate positions. A new ethic and aesthetic existence was imposed as well as a new technical demand. There was no "market" for this type of artistic production. The collector was not accustomed to purchasing works on paper, knowing that traditionally these were considered insignificant. In short, it was a revolutionary process for art in Venezuela.

• Drawing in the decade of the seventies diverted the traditional taste for painting, and works on paper began to be appreciated for themselves. In many ways it liberated a certain petrifying aspect of the national art. By not being submissive to the market, the artist-draftsman felt the liberty to use his creative power. This power was an irreversible force that marked a radical tendency towards the definitive imposition of the profoundly expressive subject and idea. From this moment on the viewer had the opportunity of establishing another dialogue with the work of art. He learned to value the artistic object more than the pictorial or sculptural work.

• Many artists appear on the Venezuelan drawing scene from the beginning of the seventies. Some of them exhibited in the first Biennials dedicated to this medium. Among them are Felipe Herrera, Saúl Huerta, Ernesto León, and Corina Briceño. However, we cannot leave behind a generation of a few artists who led the way, including such outstanding artists as Alirio Palacios and Edgar Sánchez. Since the seventies these artist-draftsmen formulated a thematic, personal, and reflective language about existential reality as artists and as contemporary Venezuelans. This language

needed a formal expression that would serve them as a visual vehicle. And Sánchez as well as Palacios transgressed the traditional drawing technique to formulate a new one, based on a more agile, freer, almost more baroque line. The subject, then, found a way of presenting itself to the viewer. The work of both artists served as a base for a young generation that established with monochromatic figurative work a dialectical and realist language. The contribution of both these generations to the Venezuelan fine arts has been conclusive. One of the important points is that the majority of the artists who began as draftsmen still continue to draw. This is a fundamental issue, since generally the painter produces drawings as a break from the task of painting as do sculptors. Logically we cannot affirm that these drawings are deprived of artistic value, but they do not have the same vision of an artist-draftsman in relation to the drawing than that of another who practices many media.

• In Venezuela since 1970, the "boom" of drawing produced a refreshing air to the artistic ambience. The proliferation of very good artist-draftsmen led to the opening up of museums, private galleries, collectors, and cultural institutions. Prizes in the National Biennials were created and various regional halls arose that strongly urged the

continuance of drawing. Today it can be said that the initial energy continues although some artists have taken the route of painting. The three artists that are presented in this exhibition are well established in the Venezuelan art scene. Until now, each has produced work of significant and fundamental value. But we would also need to say that each one belongs to a different generation, while none arose from the great generation of drawing in the seventies in Venezuela. The three are strong draftsmen, but do not work exclusively in that medium. They do painting, sculpture, graphics, and drawing. In the case of Damast and Zerpa, one has to also count their experiences in the creation of installations. In much of their work, it is difficult to discern which are the limits as to the technique of the work they produce, above all with drawing. In some of the drawings produced presently, the task of distinguishing drawings from paintings becomes difficult.

• Taking into account the different backgrounds of Oswaldo Vigas, Elba Damast, and Carlos Zerpa, it may be confirmed that their work is related, especially by a certain amount in the fantastic and the religious. In Vigas his characteristic theme of the female figure is related to the ancestral "Madonna." Here it takes the character of a contemporary icon, likewise, the feminine or masculine figure that Zerpa presents in his works of today. Being irreverent, Zerpa works

with the topic of the contemporary man, invert-
ing his roles in the scenery of everyday life. For
her part, Elba Damast constructs a universe
full of real and symbolic energies. The force of
the line and the color is important in her work.
With both of these, she creates an expression-
istic abstract and figurative space that repre-
sents the conjunction of the materials appearing
rough, and transforms them into a mysterious
poetry. The work of Damast is not about the
surface. On the contrary, it is work that must be
read from inside to outside. It is how the artist
works in reality.

• In conclusion, it can
be affirmed that the works of these three artists
have contributed to enrich the artistic medium in
Venezuela. They form part of a new generation
of artists that this country has produced.

BÉLGICA RODRÍGUEZ
Director, Museum of Modern Art of Latin America, Washington, D.C.

Latin American Drawings Today

RODOLFO ABULARACH

Guatemala, b. 1933

Madre

1990
color pencil

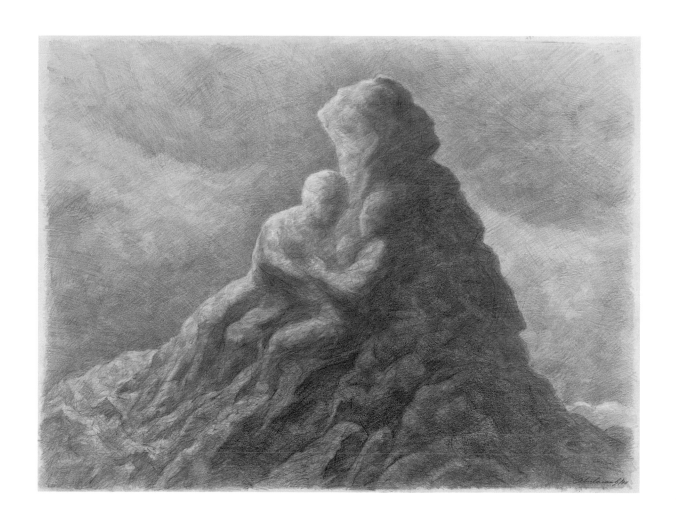

30

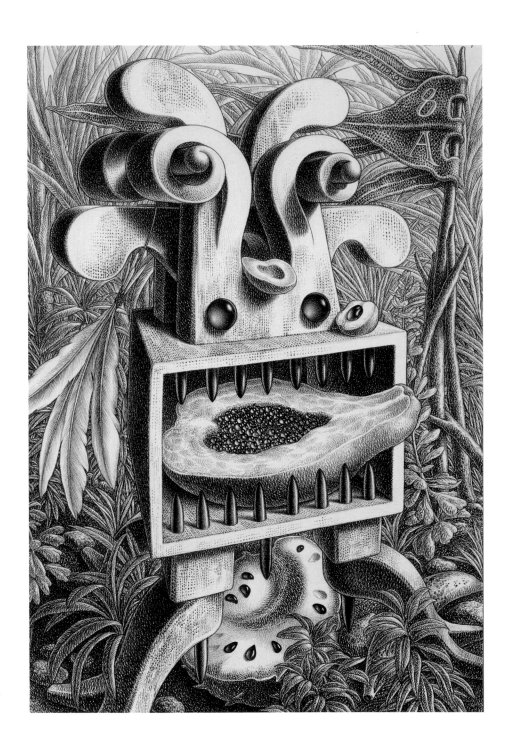

Cuba, b. 1943

Fatum (Destiny)

1990
pierre noire

La conquista (The Conquest)

1990
pierre noire

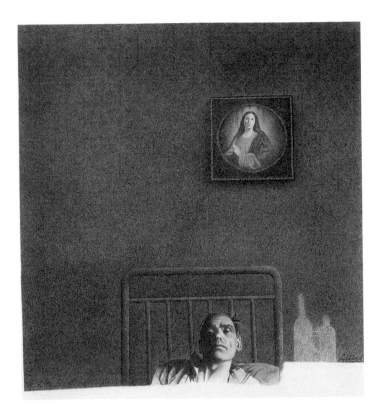

Argentina, b. 1954

El enfermo

1986
ink and gouache

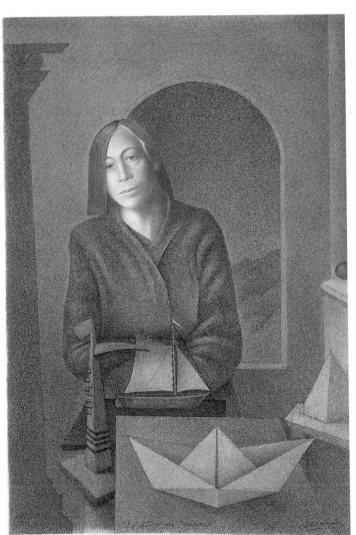

El ático de Misram

1989
ink and gouache

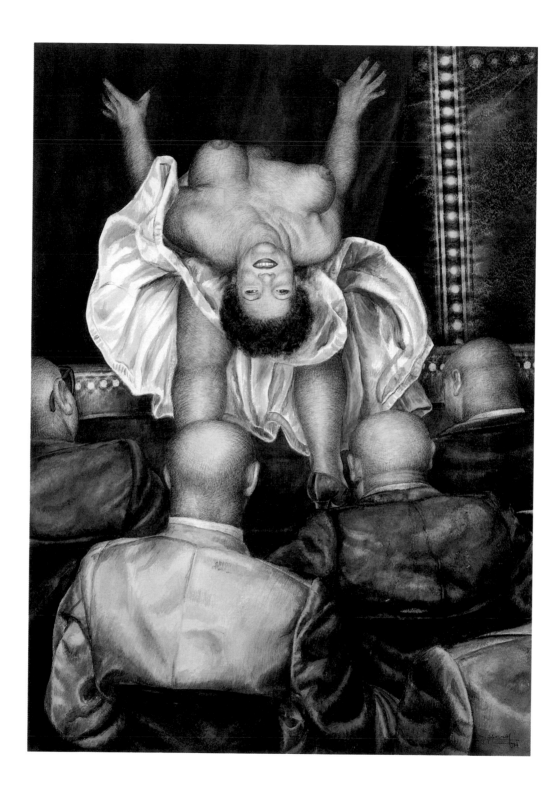

Argentina, b. 1949

Contortionista

1979
ink and gouache

Brazil, b. 1935

Flying Parts

1985
oil pastel

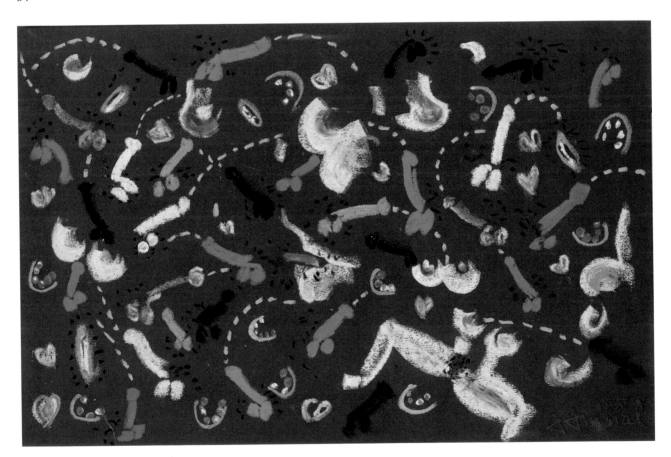

Hearts and Fish

1984
oil pastel

35

Colombia, b. 1949

Untitled

1990
pencil, wax crayon, and acrylic

36

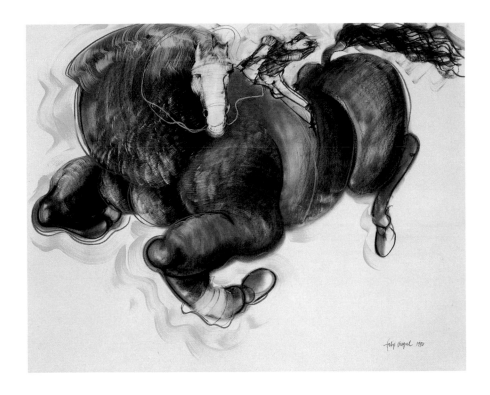

FÉLIX ANGEL

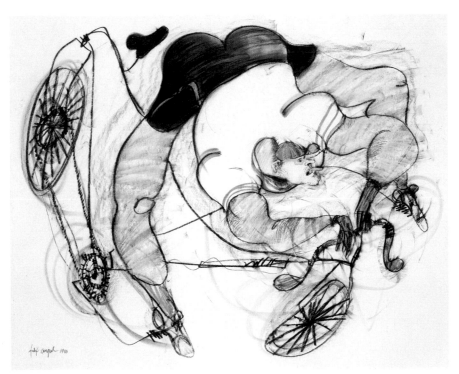

Untitled

1990
pencil, wax crayon, and acrylic

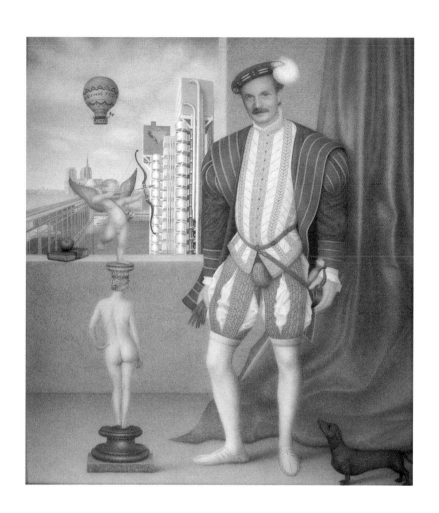

Perú, b. 1947

Portrait of a Conquestador

1990
mixed media

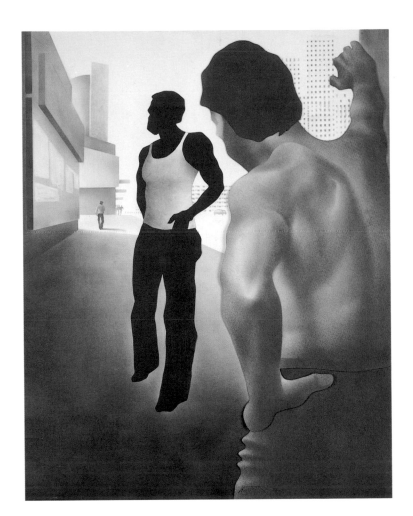

Colombia, b. 1948

Sábado

1986
pencil

38

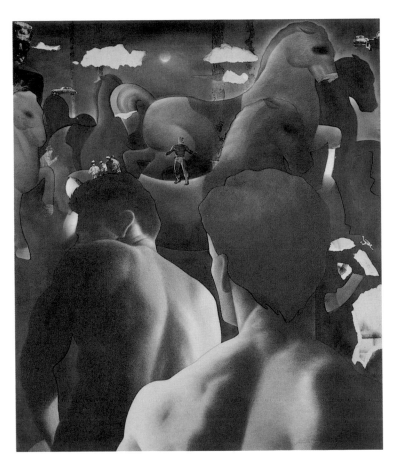

Ho-Ménage à Trois II

1988
pencil

ALVARO BARRIOS

Colombia, b. 1945

Jupiter transforma en estrellas a las hijas de Atlas

1989
ink and watercolor

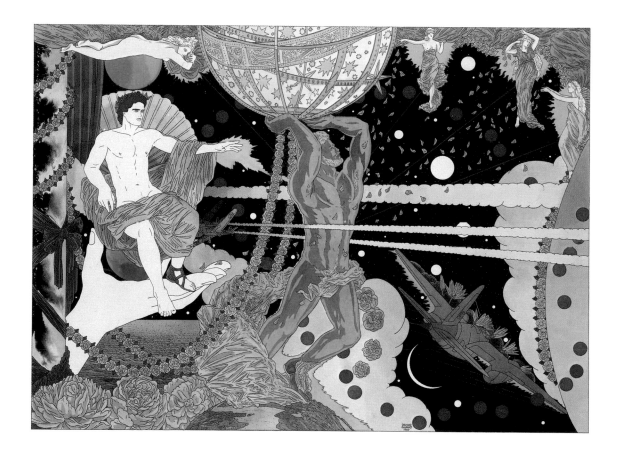

40

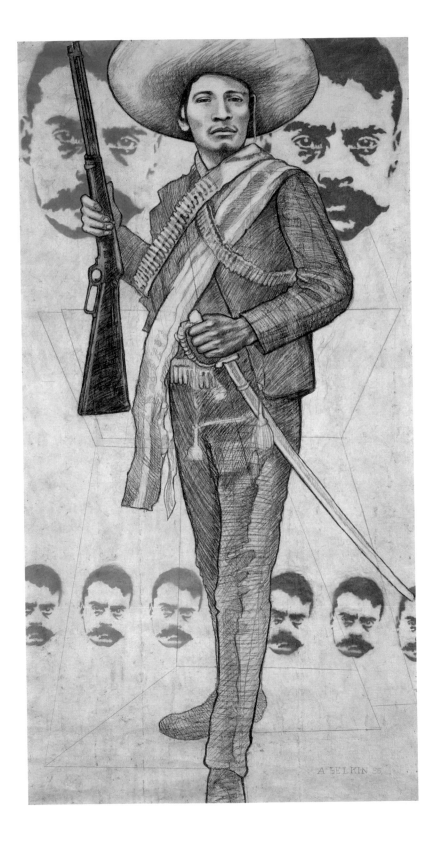

México, b. 1930

#2 Serie Lucio Cabañas

1985
mixed media

Argentina, b. 1937

El lazo como instrumento de la conquista

1985
watercolor

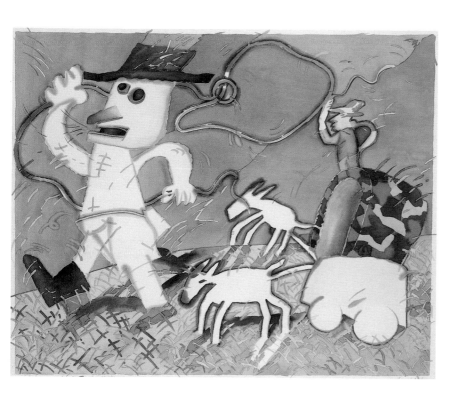

T.A. segundo version

1990
pencil

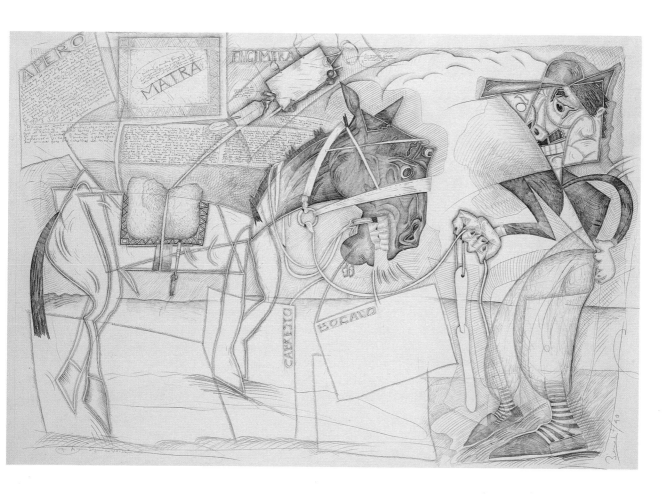

42

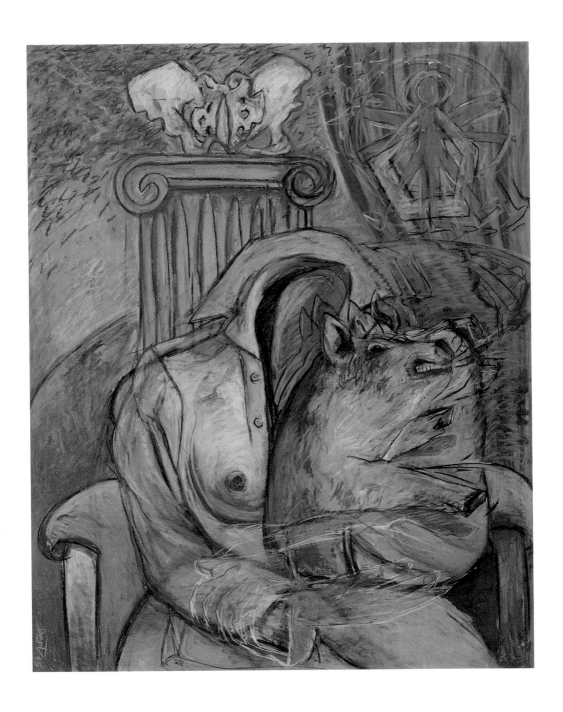

Chile, b. 1957

Lady and the Pig

1985
pastel

The Meaning of His Absence

1985
pencil

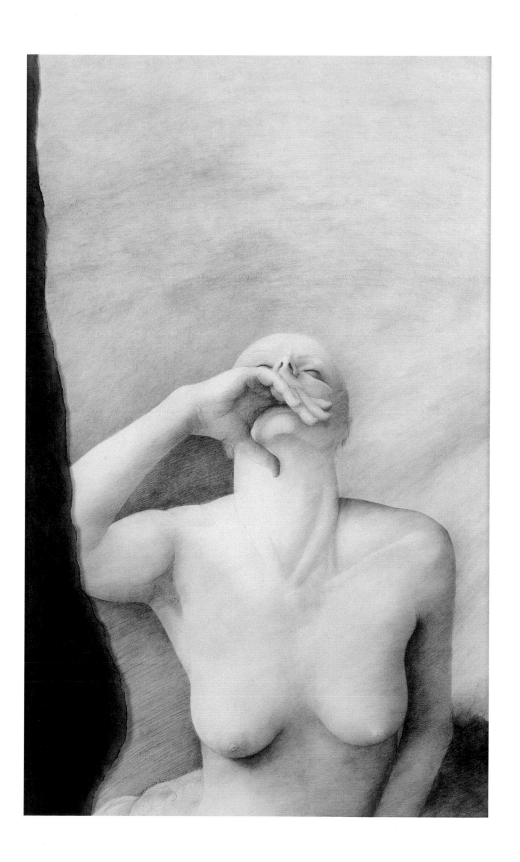

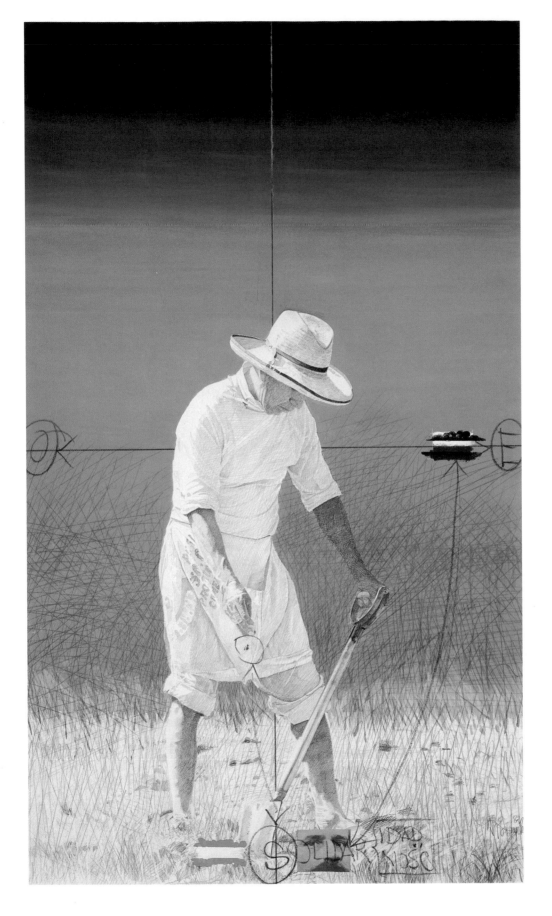

El sembrador

1981
pencil and acrylic

Perú, b. 1933

¡Hasta que no les quede una pluma! (Ya van desplumados - Goya)

1990
pencil and acrylic

HERMAN BRAUN-VEGA

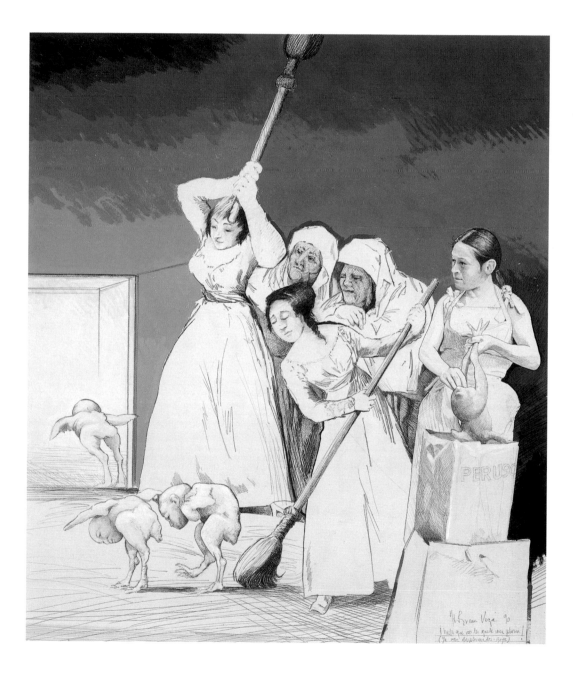

CLAUDIO BRAVO

Chile, b. 1936

Seated Male from Back

1982
pencil

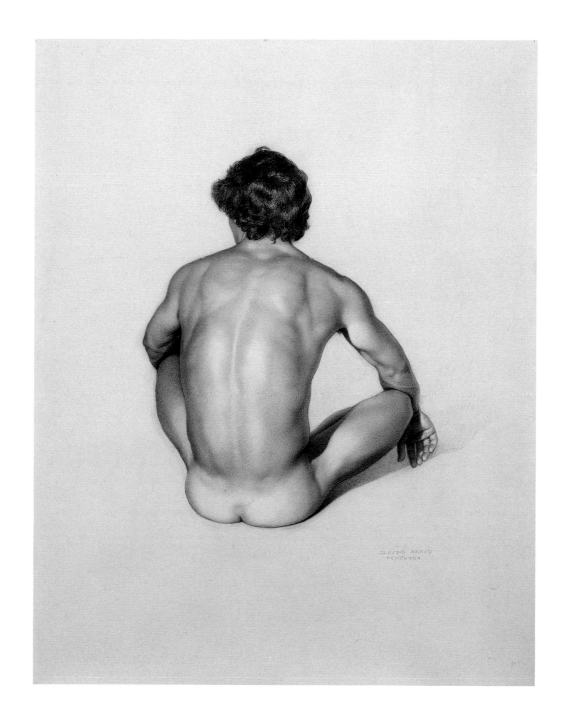

Colombia, b. 1943

Untitled

1988
colored pigments

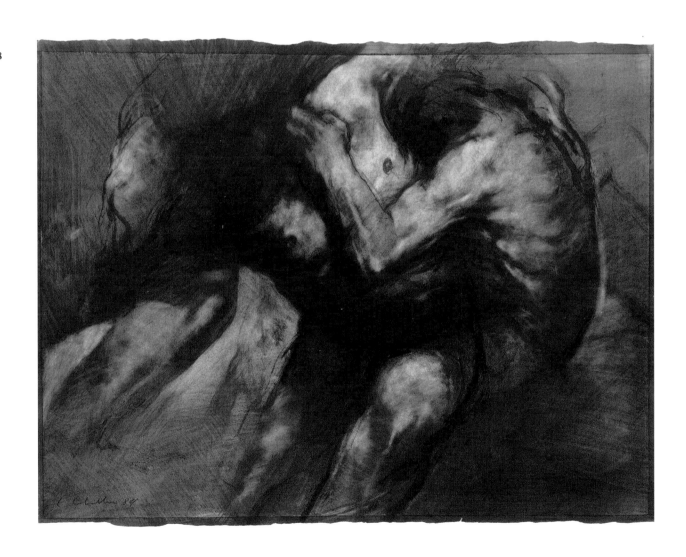

Untitled

1988
colored pigments

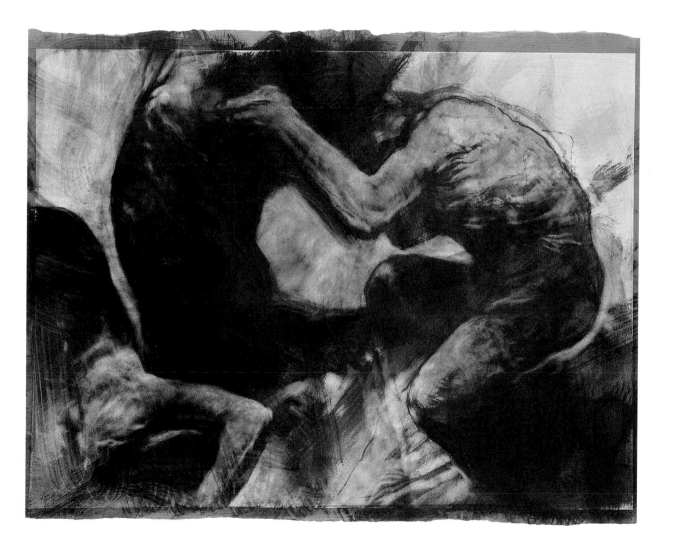

50

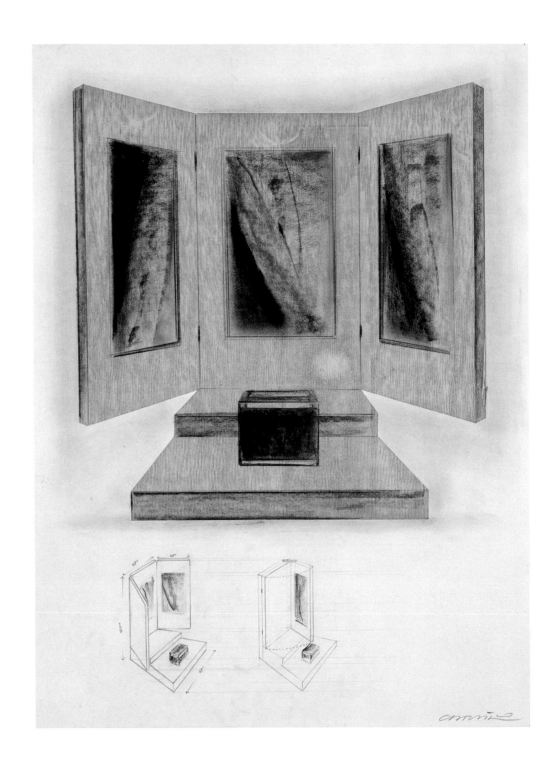

Uruguay, b. 1944

Memorial I, Triptych

1988
graphite, pencil, and collage

52

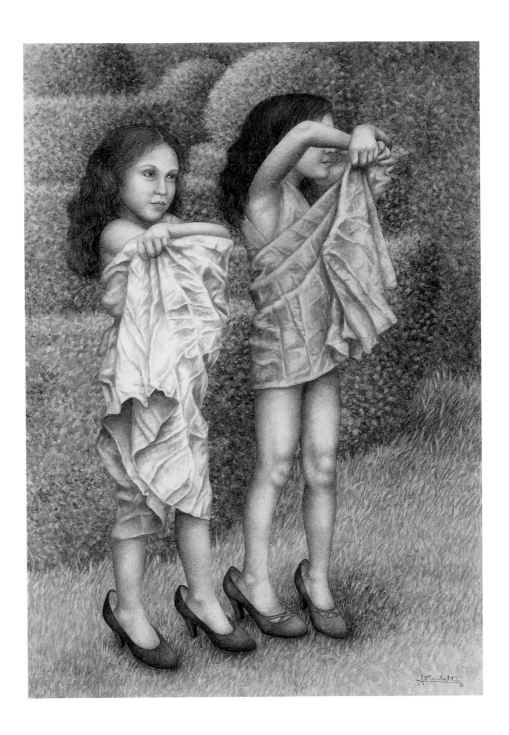

Argentina, b. 1946

Juegos en el jardin

1983
watercolor

JOSÉ CASTRO LEÑERO

México, b. 1953

Travesía

1990
ink

53

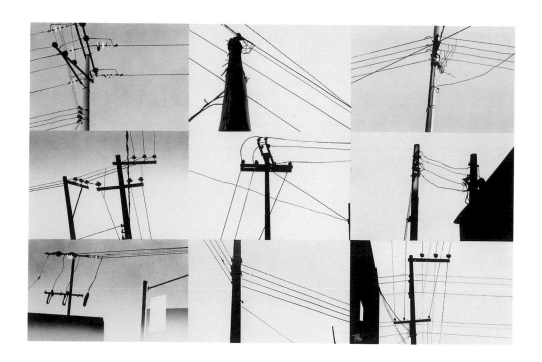

Blues de la calle (9) nueve

1990
ink

Venezuela, b. 1944

Pregnant by Her Own Reality

1990
mixed media

54

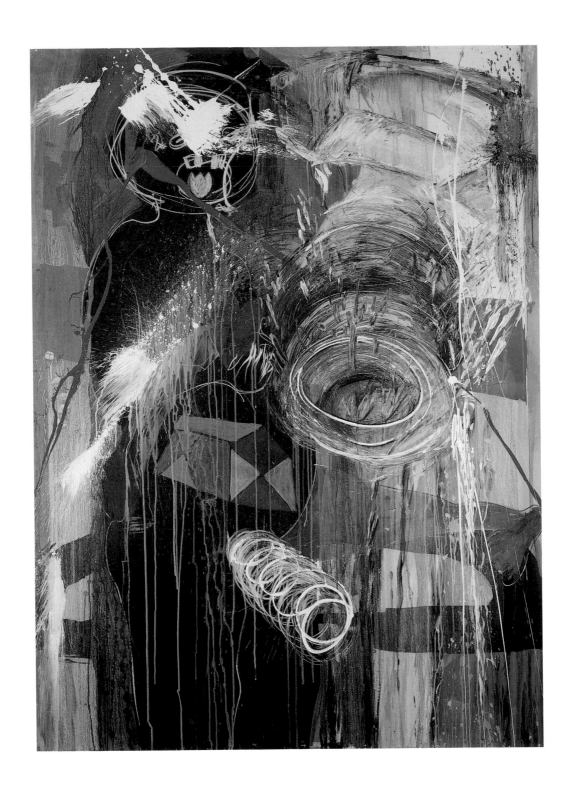

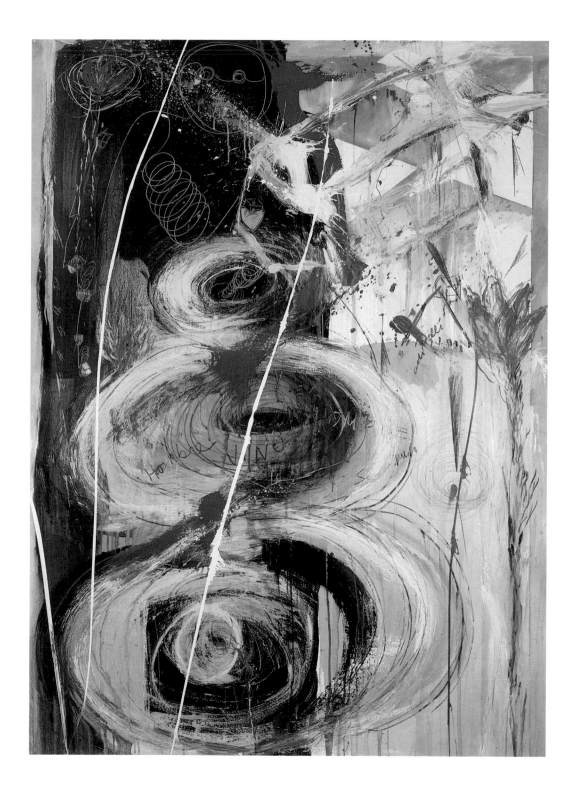

Uruguay, b. 1931

Vision III

1988
acrylic and graphite

JORGE DAMIANI

56

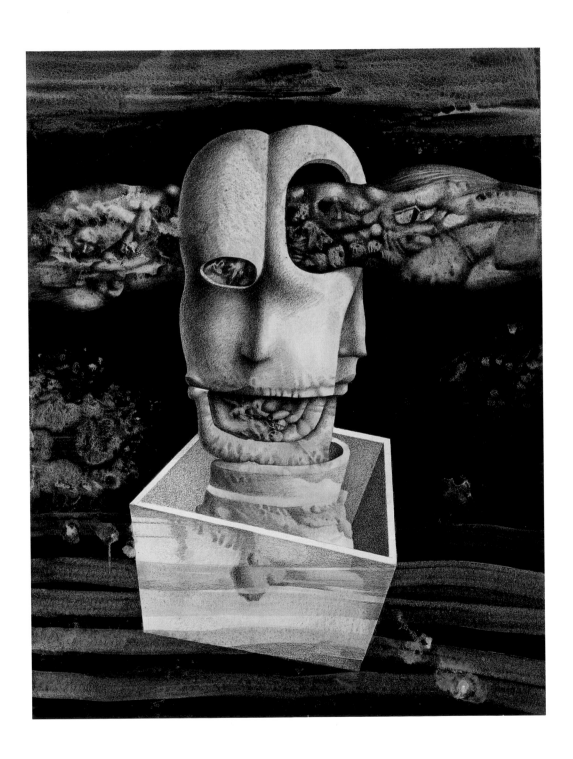

México, b. 1928

Mares

1989
crayon and charcoal

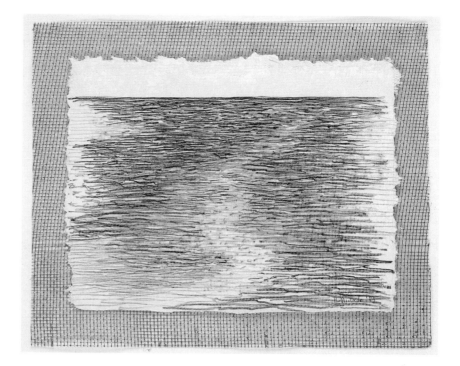

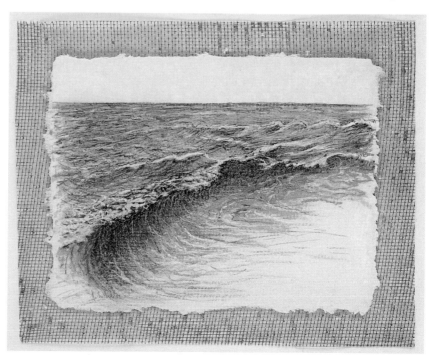

Mares

1989
crayon and charcoal

58

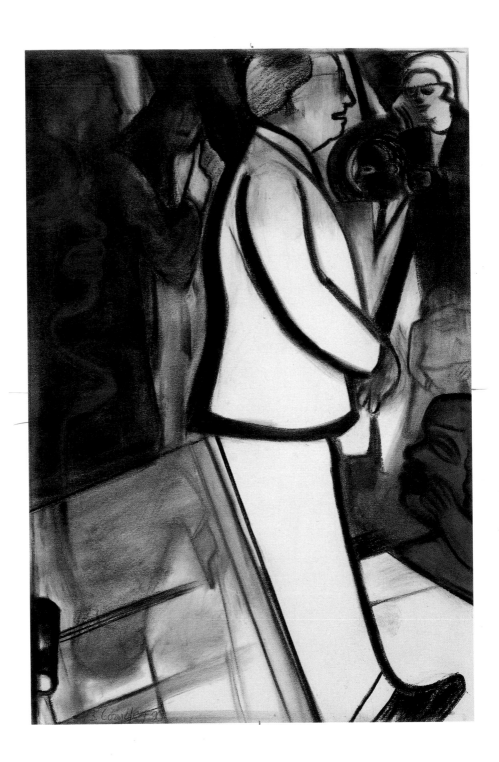

Colombia, b. 1938

Palaciegos

1990
charcoal and pastel

Sr. Presidente que honor estar con UD. en este momento histórico

1986
pastel and charcoal

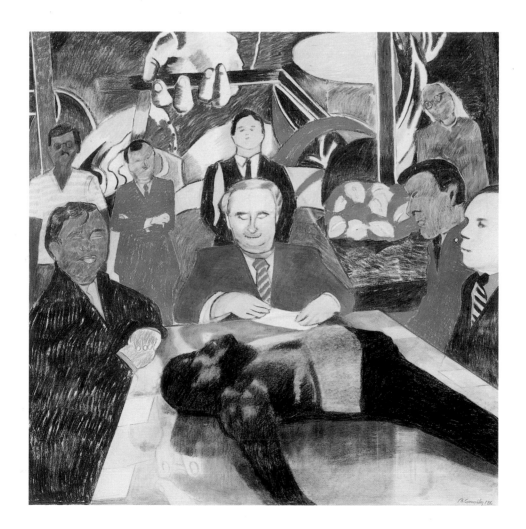

Colombia, b. 1920

El ajustador rosado

1990
charcoal and pastel

60

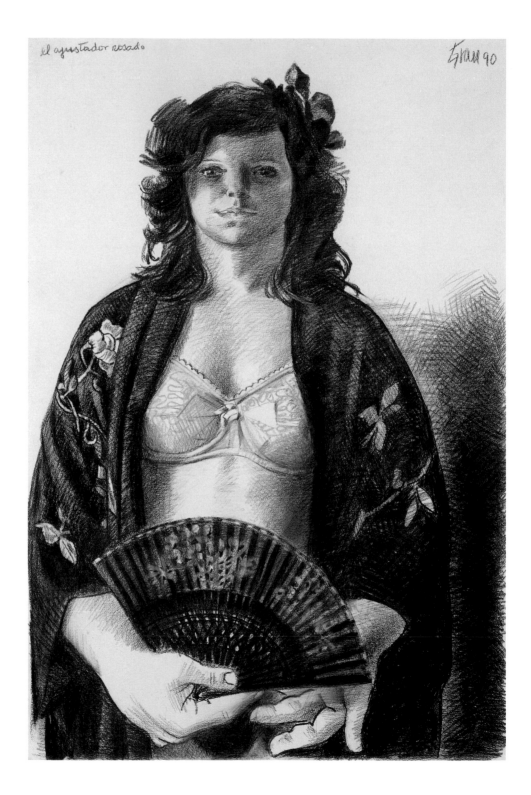

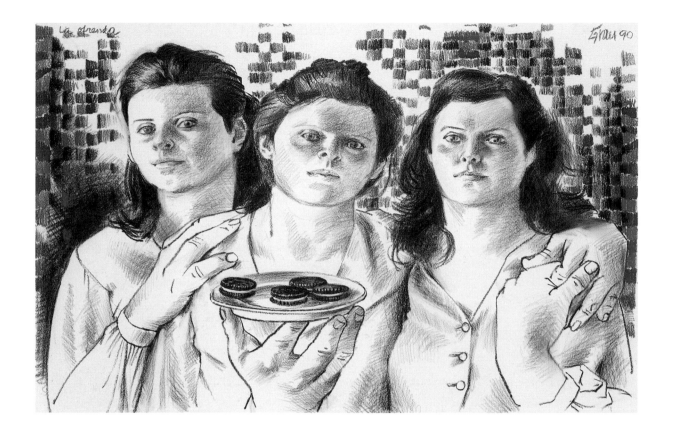

La ofrenda

1990
charcoal and pastel

RAFAEL HASTINGS

62

Perú, b. 1949

Disorder

1984
conte, pencil, and charcoal

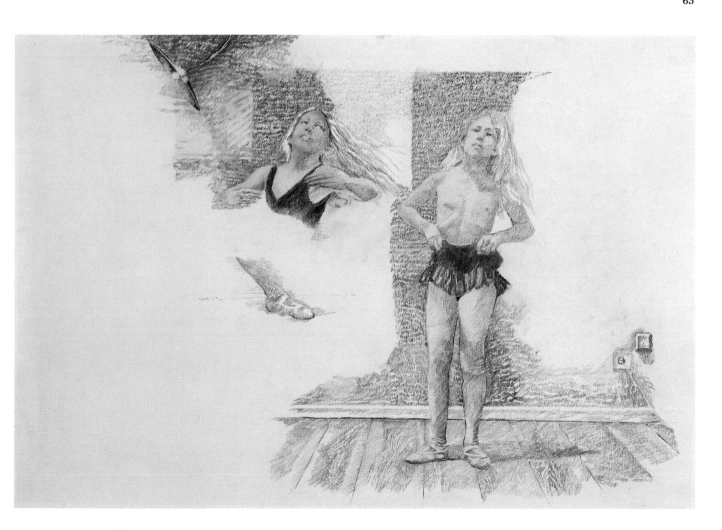

Chile, b. 1939

Por los dios del fin del mundo

1990
pastel, crayon, charcoal, and pencil

América de cuerpo pintada

1989
pastel, crayon, and charcoal

64

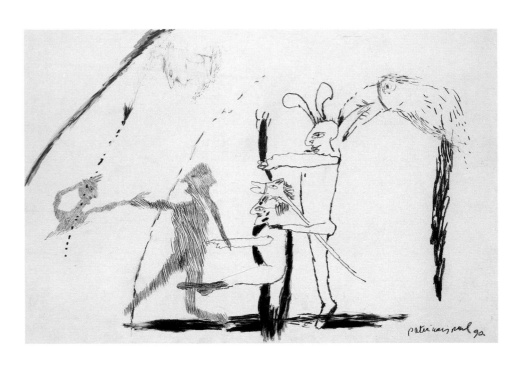

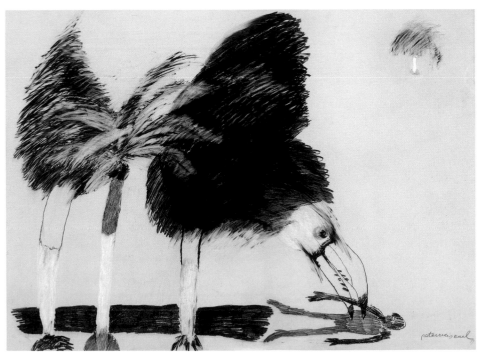

65

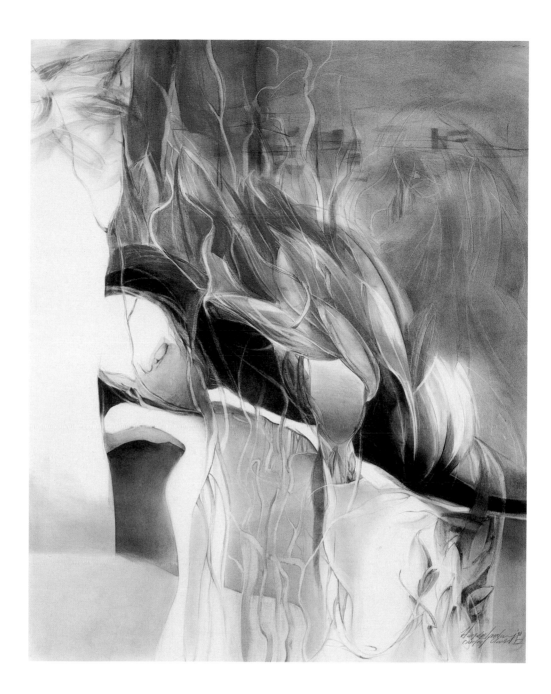

HAYDEE LANDING

Puerto Rico, b. 1956

Ciudad olvidada I

1990
charcoal, crayon, and graphite

Mango Tree

1990
charcoal

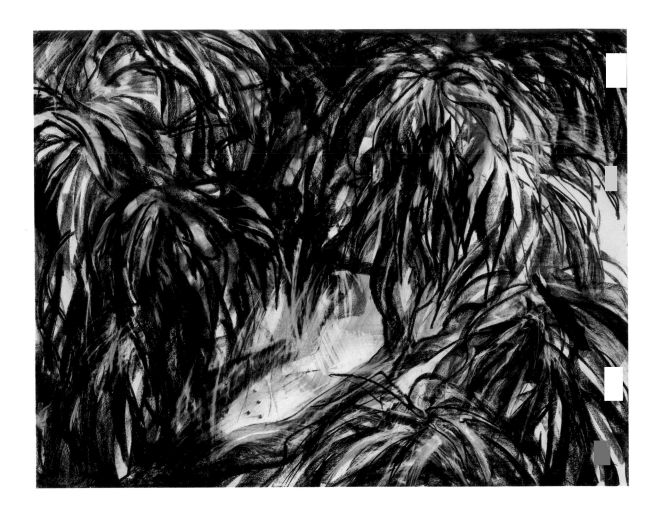

ANTONIO MARTORELL

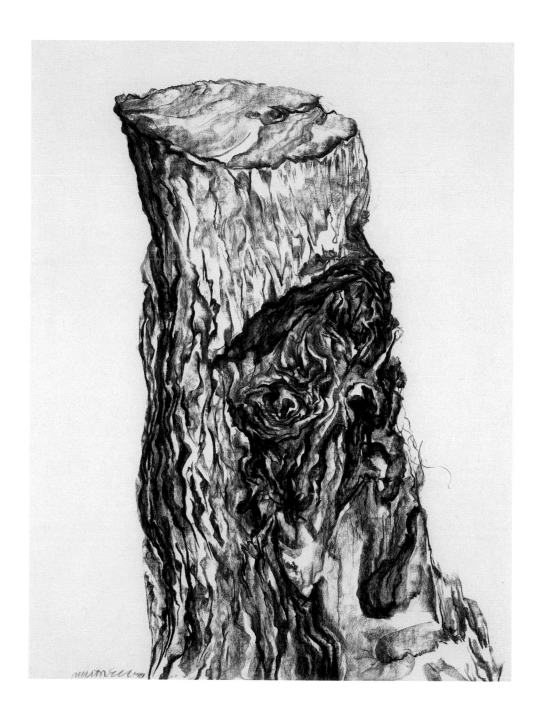

67

Puerto Rico, b. 1939

Tree Stump

1990
charcoal

68

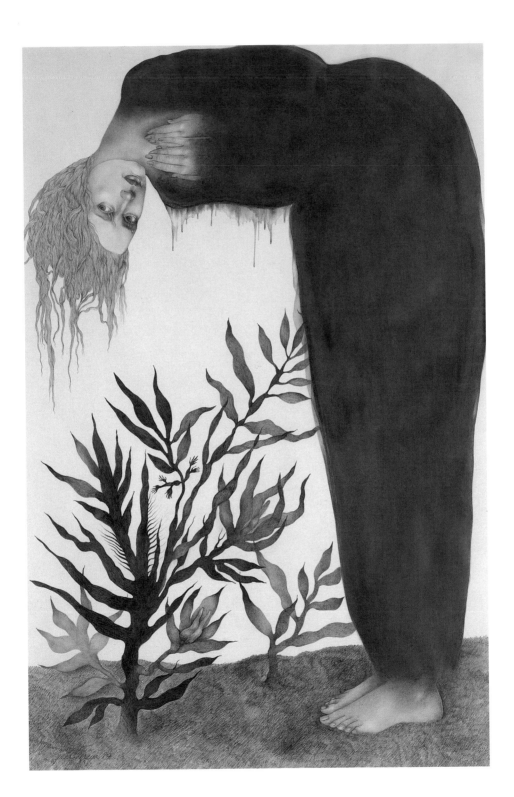

México, b. 1953

Madre del olvido

1987
pencil

Verde lino

1989
pastel

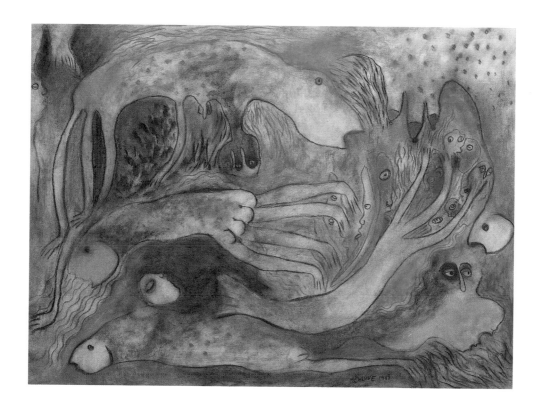

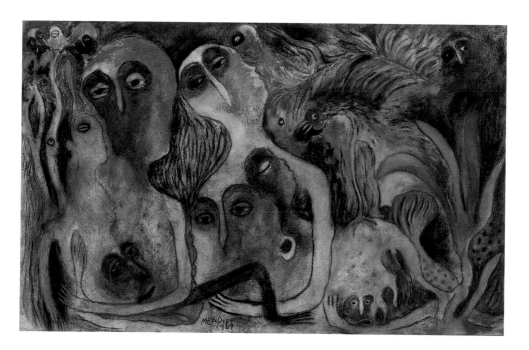

Gallina de cabeza rota

1989
pastel

Chile, b. 1930

De la serie "suite de Boësses"

1985
ink, color pencil, and acrylic

70

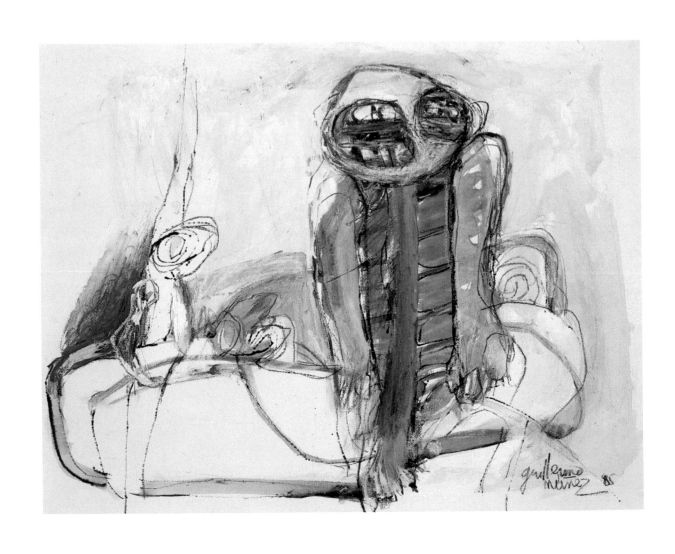

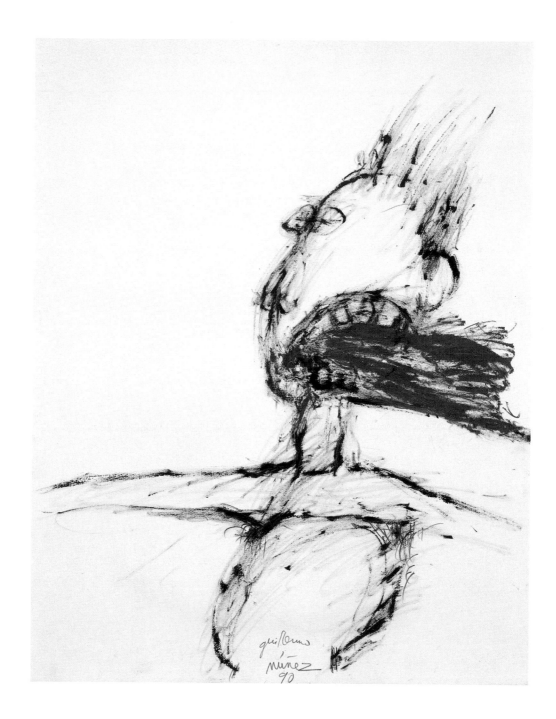

De la serie "le dejeuner sur l'herbe"

1990
ink and color pencil

LILIANA PORTER

Argentina, b. 1941

The Other One

1990
pencil, charcoal, ink, and collage

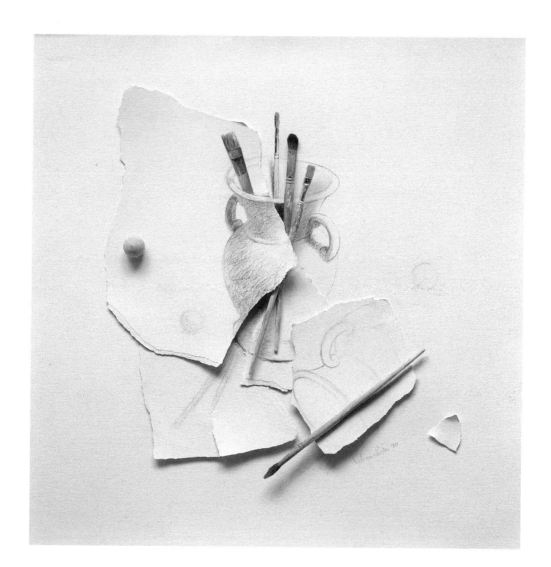

FRANCISCO DE LA PUENTE

74

Chile, b. 1953

Untitled

1988
mixed media

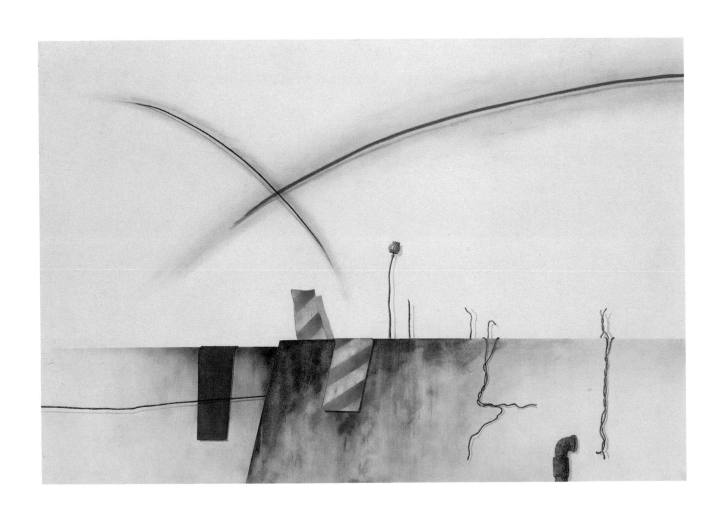

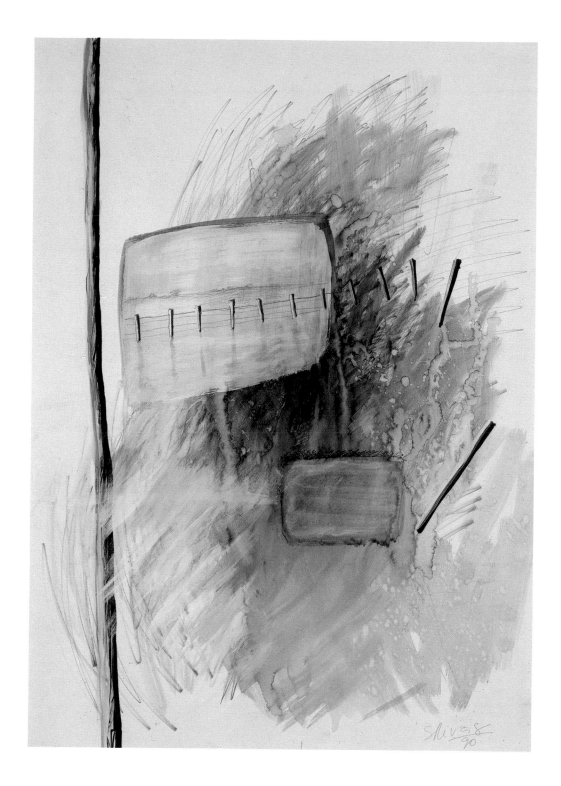

SILVIA RIVAS

Argentina, b. 1957

Un infinito en otro

1990
ink marker

76

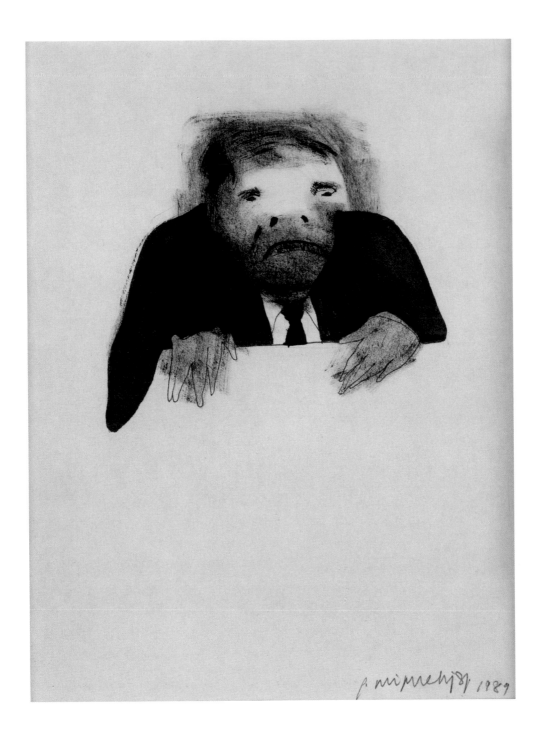

Esperando a...

1989
ink

Costa Rica, b. 1959

Conversando con...

1989
ink

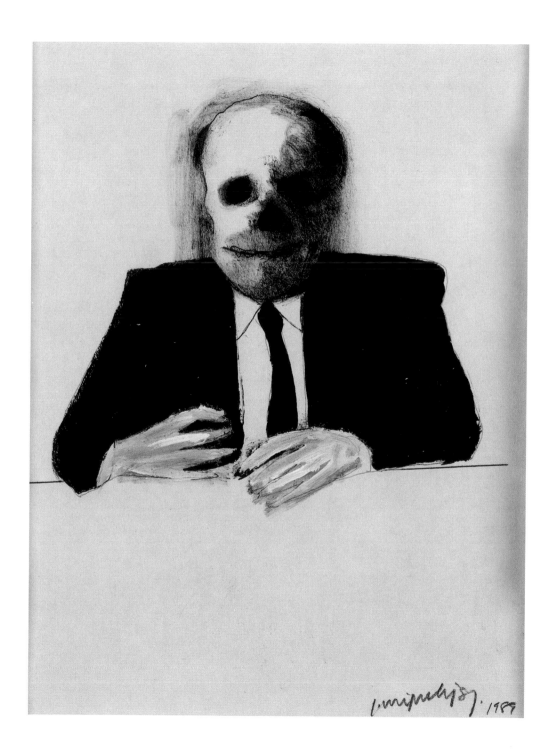

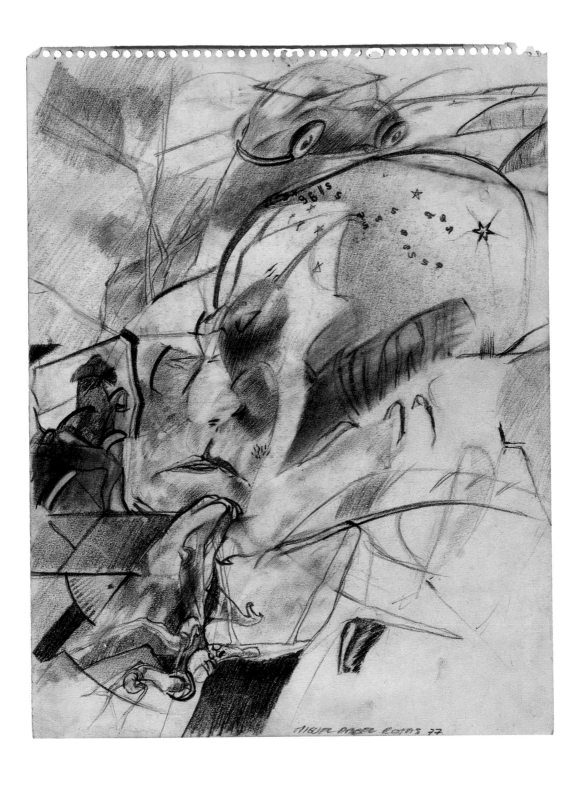

Colombia, b. 1946

Autorretrato en camino

1977
graphite

MIGUEL ANGEL ROJAS 79

Guatemala, b. 1945

Desaguadero I

1989
watercolor and mixed media

80

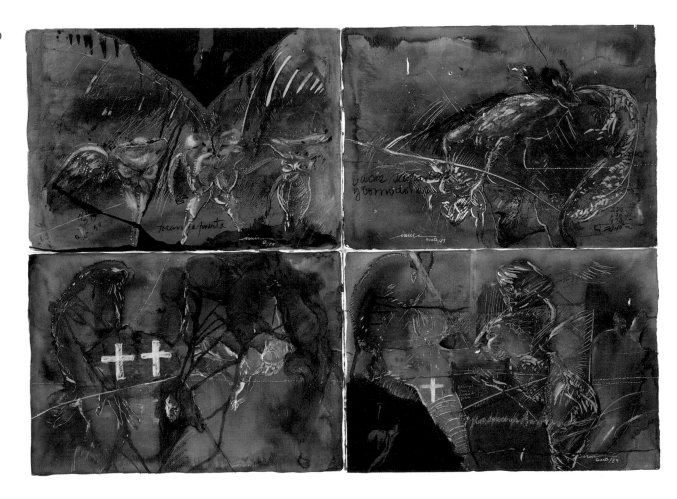

Historia sitiada

1990
watercolor

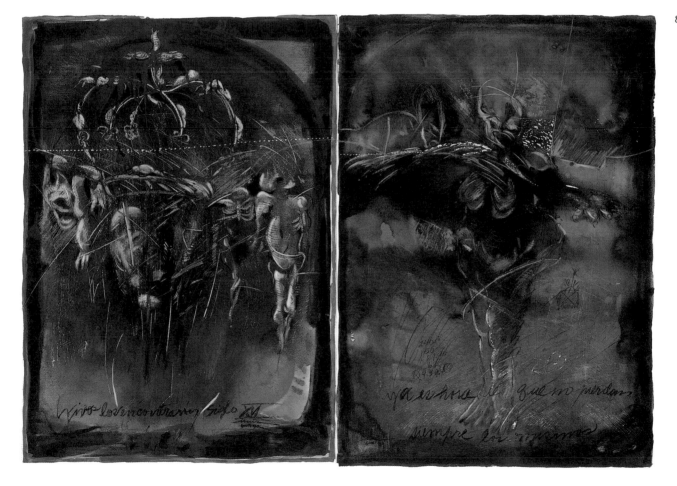

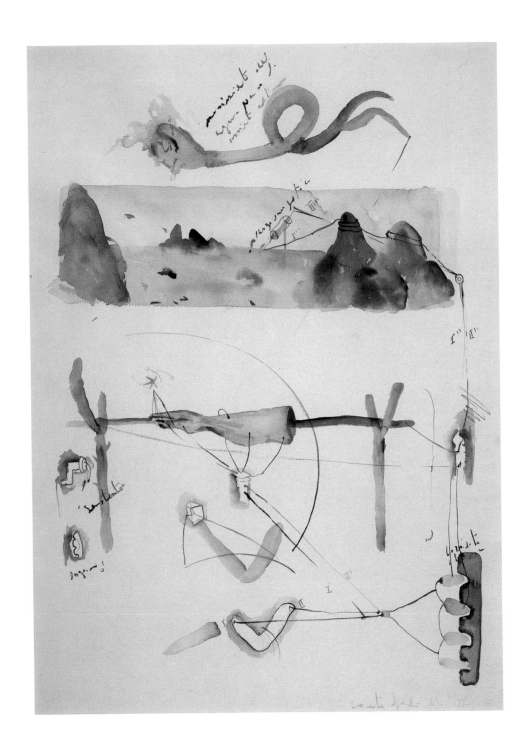

Chile, b. 1958

Ése arte filo

1988
watercolor

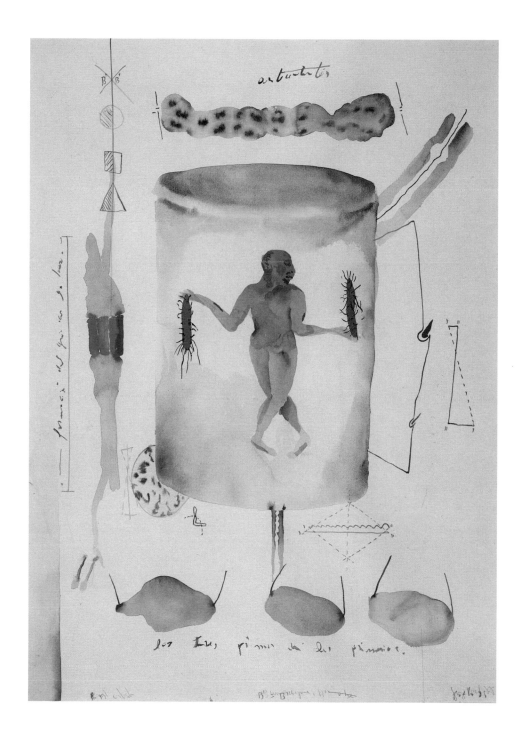

México, b. 1940

La máquina de coser de Dona Flor

1987
gouache

FRANCISCO TOLEDO

84

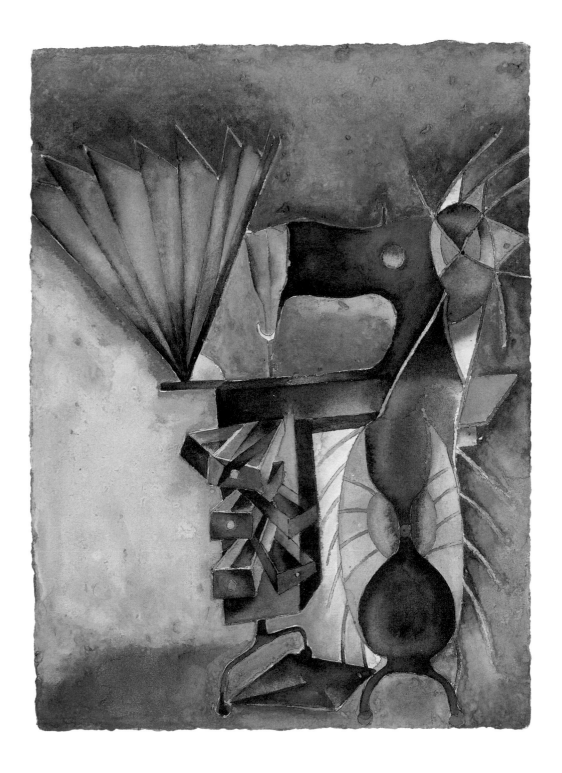

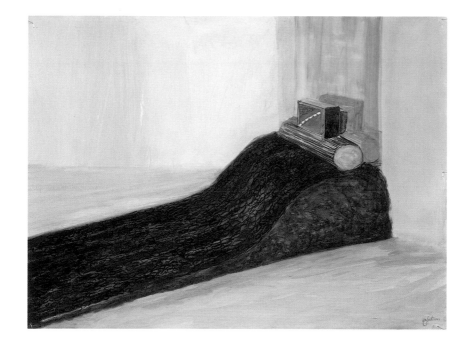

Anakonda

1989
acrylic

Brazil, b. 1943

REGINA VATER

Dead Cargo

1989
acrylic

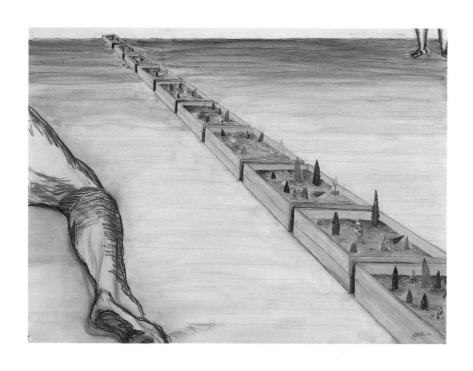

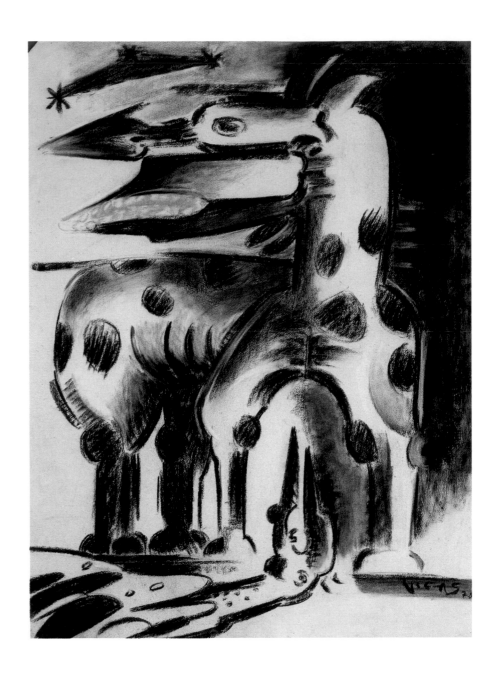

Venezuela, b. 1926

Animal

1978
charcoal and sanguine

OSWALDO VIGAS

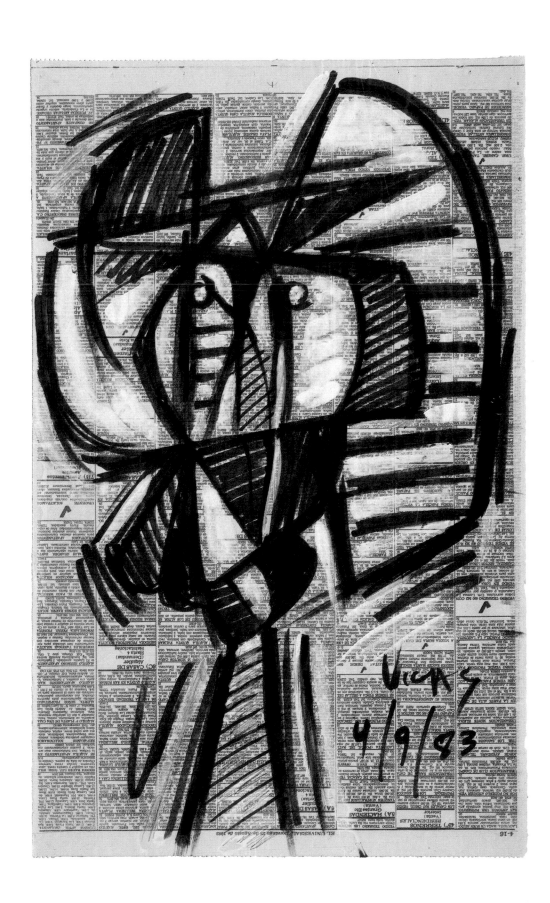

Venezuela, b. 1950

Pop-Top

1984
acrylic

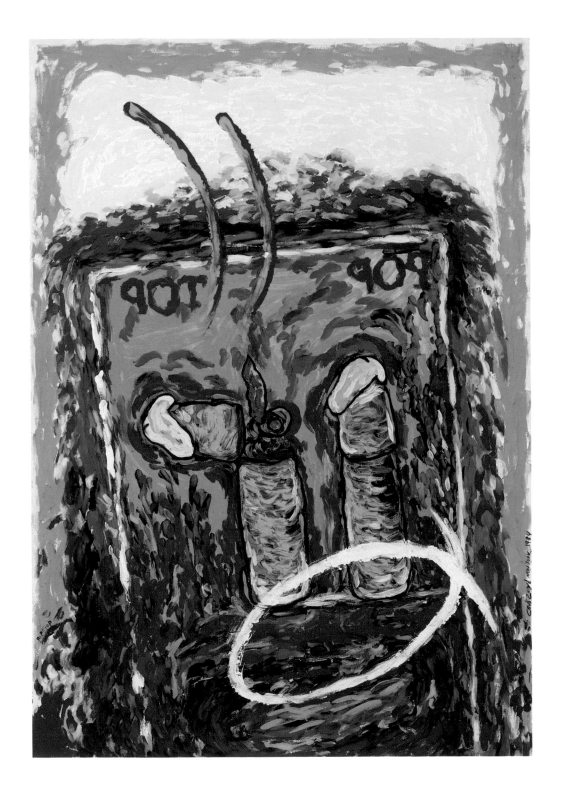

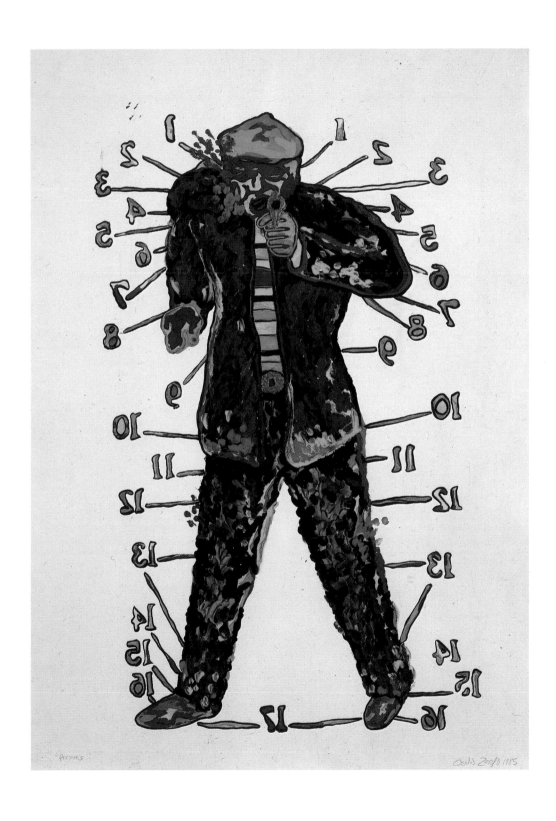

Personaje

1985
acrylic and ink

Latin American Drawings Today

RODOLFO ABULARACH

b. Guatemala City, Guatemala, 1933 (in New York since 1959)

Studies: National Art School and School of Architecture, University of San Carlos, Guatemala. **Exhibitions:** 1990 Gallery Camleyben, Frederikstad, Norway; 1989 El Tunel Gallery, Guatemala City (solo); *MIRA,* Hispanic Art Tour (traveling exhibition); 1988 The Latin American Spirit, Art and Artists in the United States, 1920-1970, The Bronx Museum, New York; Patronato de Bellas Artes Gallery, Guatemala City (solo); 1986 National Museum of Art, La Paz, Bolivia (solo); 1977 Creadores Contemporáneos Latinoaméricanos, Museum of Modern Art, México, D.F.; 1974 Museum of Modern Art, Bogotá (solo). **Collections:** Museum of Modern Art, New York; Museum of History and Fine Arts, Guatemala City; San Diego Museum of Art

RAMÓN ALEJANDRO

b. Havana, Cuba, 1943 (in Paris since 1963)

Studies: self-taught; studied printmaking with Friedlander in Paris. **Exhibitions:** 1990 *Images, Magies, Présence Contemporaine,* Aix en Provence; 1989 Osuna Gallery, Washington, D.C. and Miami (solo); 1988 Galerie Minotauro, Caracas (solo); Triennial, Sofia; 1988 and 1987 Galerie du Dragon, Paris (solo); 1987 *Outside Cuba/Fuera de Cuba,* Rutgers University, New Jersey; 1984 FIAC; 1980 Galerie Arte, Geneva (solo). **Collections:** Bibliothèque Nationale, Paris; Musée d'Art Moderne de la Ville de Paris

FERNANDO ALLIEVI

b. Argentina, 1954

Studies: Escuela Provincial de Bellas Artes "Figueroa Alcorta," Córdoba, Argentina. **Exhibitions:** 1984 Galería del Retiro, Buenos Aires (solo); CAJAS, Centro Cultural General San Martín, Buenos Aires; 1984 Galería Jaime Conci, Córdoba, (solo); Arte Joven, Museo Emilio Caraffa, Cordoba; Premios APAC, Museo Genaro Pérez, Córdoba; La Pintura Joven, Galería del Retiro, Buenos Aires; 1982 Galería del Retiro, Buenos Aires (solo); Arte Joven, Museo Emilio Caraffa, Córdoba; 1981 Galería ELE, Córdoba (solo); 1980 Galería ARP, Río Cuarto, Argentina (solo); XIX Premi Internacional de Dibuix Joan Miró, Barcelona; *3 Dibujos,* Galería ELE, Córdoba; 1979 Salón Nacional de Rio Cuarto, Córdoba

JORGE ALVARO

b. Buenos Aires, Argentina, 1949

Studies: National School of Fine Arts "Manuel Belgrano;" National School of Fine Arts "Prilidiano Pueyrredon." **Exhibitions:** 1979 Bonino Gallery, New York (solo): 1978 Art Critics Association, special mention; 1977 Bonino Gallery, Argentina (solo); Martha Zullo Gallery, Argentina; X Biennal, Paris; 1976 Louisiana Museum of Modern Art, Copenhagen; Joan Miró Foundation, Barcelona; Museum of Modern Art, San Francisco; 1975 Bonino Gallery, Argentina (solo); *Argentina 75,* Agora Gallery, Maastricht, Holland; *Dibujantes Argentinos,* Corcoran Gallery, Washington D.C.; 1974 Martina Cespedes Gallery, Argentina (solo)

ANTÔNIO HENRIQUE AMARAL

b. São Paulo, Brazil, 1935

Studies: workshop, Museu de Arte Moderna, São Paulo. **Exhibitions:** 1990 Brazil-Japan Contemporary Art Exhibition, Tokyo, Saporo, Atami, Rio de Janeiro, São Paulo; 1989 Elite Fine Art Gallery, Coral Gables, Florida; 1988 and 1989 *Brasil Ja*, Leverkusen, Stuttgart, Hannover; 1988 and 1987 *Art of the Fantastic: Latin America 1920-1987*, Museum of Indianapolis; 1987 Montesanti Gallery, São Paulo (solo); 1984 National Arts Centre, Ottawa (solo). **Collections:** Museu de Arte Moderna de Rio de Janeiro; Casa de las Américas, Havana

FÉLIX ANGEL

b. Medellín, Colombia, 1949 (in Washington, D.C. since 1977)

Studies: Universidad Nacional de Colombia, Medellín (architecture). **Exhibitions:** 1990 Moss Gallery, San Francisco; 1988 Museo de Arte e Historia de San Juan, Puerto Rico (solo); Museo de Antioquia, Medellín (solo); 1987 VII Biennal Internacional de Arte de Valparaíso, Chile; 1986 Galería Iriarte, Bogotá (solo); 1985 Galería 1-2-3, San Salvador, El Salvador (solo); 1983 Galería Arte Autopista, Medellín. **Collections:** San Francisco Museum of Modern Art; Detroit Institute of Art; Museum of Modern Art of Latin America, Washington, D.C.

HUMBERTO AQUINO

b. Lima, Perú, 1947 (in New York since 1977)

Studies: Pratt Institute, New York; Cardiff College of Art, Wales; National School of Fine Arts, Lima. **Exhibitions:** 1990 Odon Wagner Gallery, Toronto (solo); 1988 *Latin American Artists in New York Since 1970*, Archer M. Huntington Art Gallery, Austin, Texas; 1978 Museum of Modern Art of Latin America, Washington, D.C. (solo); 1977 Galería Enrique Camino Brent, Lima (solo). **Collections:** The Art Institute of Chicago; Museo de Arte Contemporáneo, Bogotá; Instituto de Arte Contemporáneo, Lima

TANCREDO DE ARAUJO

b. Anicuns, Goiás, Brazil, 1942

Studies: Escolas de Belas Artes da Universidade Federal do Rio de Janeiro; Universidade Federal de Goiás. **Exhibitions:** 1988 Galeria IBEU, Rio de Janeiro (solo); 1987 Coletiva 10 Artistas, Tema Rio de Janeiro; Encontro Latino Americano, Lima; 1986 Bienal de Cali; Museu Royo, Roldanillo (solo); 1985 Salão Carioca, Rio de Janeiro; *Quando a Arte é Jóia*, Vila Roso, Rio de Janeiro; 1983 Galeria de Arte do Casino de Luso, Portugal (solo); 1982 Museu de Arte Moderna de Salvador, Bahia (solo) **Collections:** Casa da Cultura Latino Americana, Rome; Museu de Arte Moderna La Tertulia, Cali; Museu de Arte Moderna do Rio de Janeiro; Museu de Arte Moderna de São Paulo

EVER ASTUDILLO

b. Cali, Colombia, 1948

Studies: Escuela Departamental de Artes Plásticas de Cali. **Exhibitions:** 1989 *4 artistas*, Instituto Departamental de Bellas Artes, Cali; 1988 Museo Arte Moderno La Tertulia, Cali (solo); Museum of Contemporary Hispanic Art, New York; *Astudillo entra a cuadro*, video presentation for Telepacífico (solo, 60 minutes); 1987 XXXI Salón Nacional de Artistas, Medellín. **Collections:** Museo de Arte de Bogotá; Museo de Bellas Artes, Caracas; Casa de las Américas, Havana; Museu de Arte Contemporáneo de Panamá

ALVARO BARRIOS

b. Cartagena, Colombia, 1945

Studies: Universidad del Atlántico; Universidad de Perugia, Italy; La Fondazione Giorgio Cini de Venecia. **Exhibitions:** 1990 Museo de Arte Moderno La Tertulia, Cali (solo); *Colombian Contemporary Art*, Fuji Museum, Tokyo; II Bienal Latinoaméricano de Artes Gráficas, Museum of Contemporary Hispanic Art, New York; 1989 Galería Elida Lara, Barranquilla (solo). **Collections:** Museo de Arte Moderno, Bogotá; Centro Wifredo Lam, Havana; Art Gallery of Western Australia, Perth

ARNOLD BELKIN

b. Calgary, Canada, 1930 (in México since 1948)

Studies: Vancouver School of Art; Escuela de Pintura y Escultura La Esmeralda del Instituto Nacional de Bellas Artes, México. Assistant to David Alfaro Siqueiros, 1949-50.
Exhibitions: 1989 Galería Misrachi, México, D.F. (solo); 1988 Galería Espacio 1900, Puebla, México (solo); VIII Bienal de San Juan del Grabado Latinoaméricano y del Caribe, Instituto de Cultura Puertorriqueña, San Juan; 1986 Galería Metropolitana, UAM, México, D.F. (solo); II Biennal de la Habana, Cuba; 1985 Galería Arvil, México, D.F.. **Collections:** Instituto Nacional de Bellas Artes, México, Los Angeles County Museum; Museo de Ponce, Puerto Rico

LUIS BENEDIT

b. Buenos Aires, Argentina, 1937

Studies: Universidad Nacional de Buenos Aires (architecture); self-taught painter.
Exhibitions: 1990 *Arte por Artistas, 50 Obras por 50 Autores*, Museo de Arte Moderno, Buenos Aires; *Latin American Art*, The Hayward Gallery, London; 1988 *Benedit 1965-1975*, Fundacíon San Telmo, Buenos Aires (solo); *The International Art Show for the End of World Hunger*, Barbican Art Gallery, London; 1981 Los Angeles Institute of Contemporary Art (LAICA) (solo); 1975 *Projects and Labyrinths*, Whitechapel Art Gallery, London (solo)

LENA BERGSTEIN

b. Rio de Janeiro, Brazil, 1946

Studies: Escola de Artes Visuais, Rio de Janeiro; Atelier de Gravura do Museo de Arte Modernado Rio de Janeiro. **Exhibitions:** 1989 Pequena Galeria, Centro Cultural Cãndido Mendes, Rio de Janeiro (solo); 1987 Galeria Mõnica Filgueiras de Almeida, São Paulo (solo); 17th Bienal Internacional de Artes Gráficas, Ljubljana; 1986 Galeria Segno Grafico, Venice (solo); 9th Bienal Internacional de Gravura da Inglaterra, Bradford, U.K. **Collections:** Galeria IBEU; Museu Nacional de Belas Artes; Chase-Manhattan Bank

GUILLERMO BERT

b. Santiago, Chile, 1957 (in Los Angeles since 1981)

Studies: Catholic University, Santiago; Los Angeles Valley College. **Exhibitions:** 1990 Los Angeles Theatre Centre (solo); S.P.A.R.C. mural, Echo Park, Los Angeles; 1988 Museum of Contemporary Hispanic Art, New York; Downey Museum of Art, Los Angeles; 1987 Otis/Parsons Art Gallery, Los Angeles (solo); Los Angeles City College; 1986 B1 Gallery, Santa Monica; Barnsdall Art Park, Los Angeles; 1981 National Museum of Fine Art, Santiago, Chile; 1980 Catholic University, Santiago (solo); Goethe Institute, Santiago, (solo)

NORMA BESSOUET

b. Buenos Aires, Argentina

Studies: National School of Fine Arts "Manuel Belgrano," Buenos Aires; National School of Visual Arts "Prilidiano Pueyrredon," Buenos Aires; The Slade School of Fine Arts, London University. **Exhibitions:** 1989 *Norma Bessouet, Selvaggia and Uccello,* Arden Gallery, Boston (solo); *Ideas and Images from Argentina,* The Bronx Museum, New York; 1988 Museo del Barrio, New York (solo); *Up Tiempo,* Museo del Barrio, New York; 1979 Museum of Fine Arts, Caracas, Venezuela (solo)

HERMAN BRAUN-VEGA

b. Lima, Perú, 1933

Exhibitions: 1990 Galerie Pascal Gabert, Paris (solo); 1989 Galerie d'Art Contemporain Chamalières, France; Musée Henri Boez, Maubeuge, France (retrospective); Casa Ganoza, Trujillo, Perú (solo); Casa del Moral, Arequipa, Perú (solo); 1988 La Galería, Quito, Ecuador (solo); 1987 XVII Biennale Internationale de Gravure, Ljubljana, Yugoslavia; 1986 Museo de Artes Visuales, Montevideo (solo); 1986 Biennale International de Gravure, Bradford, U.K.; 1984 I Bienal de la Habana, Cuba

CLAUDIO BRAVO

b. Valparaíso, Chile, 1936 (in Tangier since 1972)

Studies: self-taught painter. **Exhibitions:** 1989 Marlborough Gallery, New York (solo); 1985 *Contemporary Narrative Figure Painting,* Moravian College, Bethlehem, Pennsylvania; 1984 Galería Quintana, Bogotá (solo); 1983 *48th Carnegie International,* Pittsburgh; 1985 Marlborough Fine Art, London; 1982 Museum of Monterrey, México (solo); 1980 FIAC, Paris; 1972 Galería Vaudres, Madrid (solo). **Collections:** Ponce Art Museum, Puerto Rico; Museum Boymans-van Beuningen, Rotterdam

LUIS CABALLERO

b. Bogotá, Colombia, 1943 (in Paris since 1968)

Studies: University of the Andes, Bogotá; Académie de la Grande Chaumière. **Exhibitions:** 1990 Galerie Garces, Bogotá (solo); Galerie Juan Martin, México (solo); Marnix Neerman Art Gallery, Bruge (solo); 1989 Musée de la Castre, Cannes (solo); 1988 Galerie Albert Loeb, Paris (solo); 1987 Minotauro Gallery, Caracas (solo); 1986 Lietzow Gallery, Berlin (solo); 1985 Galerie Pierre Huber, Geneva; 1984 represented Colombia at Venice Biennial; 1973 São Paulo Biennal

RIMER CARDILLO

b. Uruguay, 1944 (in New York since 1979)

Studies: Leipzig School of Graphic Arts, Germany; Weissenssee School of Art and Architecture, Berlin; National School of Fine Arts, Uruguay. **Exhibitions:** *Ceremony of Memory* (traveling exhibition), The Center for Contemporary Art of Santa Fe, New Mexico; 1988 *Contemporary Art from Uruguay,* Tretiakov Gallery, Moscow; 1988 Bacchus Gallery, Boras, Sweden (solo); 1987 State University of New York, Purchase (solo). **Collections:** The Art Institute of Chicago; Museum of Modern Art, New York

ALICIA CARLETTI

b. Buenos Aires, Argentina, 1946

Studies: Escuela de Artes Visuales Augusto Bolognini; Escuela Nacional de Bellas Artes Prilidiano Pueyrredon. **Exhibitions:** 1990 Arts Internationale, Santa Fe, New Mexico (solo); *Genero: femenino, profession, artista plástica,* Museo de Arte Moderno; *Artistas de Buenos Aires,* Museo de Arte Moderno de México; Museo La Tertulia, Cali; Museo de Arte Moderno de San Pablo; 1989 *Ideas and Images from Argentina,* The Bronx Museum of the Arts; 1986 Bienal latinoaméricana de arte sobre papel, Salas Nacionales de Exposicion; 1984 Buenos Aires through its writers, artists, and architects, Academy of Fine Arts, Berlin; 1983 Bonino Gallery, New York (solo); 1980 Galeria Buen Ayre (solo)

MARIA DO CARMO SECCO

b. São Paulo, Brazil

Studies: Escola Nacional de Belas Artes; Museu de Arte Moderna; Escolinha de Arte do Brasil (all Rio de Janeiro). **Exhibitions:** 1981 *Casa do Brasil,* Galleria d'Arte, Rome (solo): 1980 Biennale del Messico; 1979 Multimedia Internacional, Museo di Arte Moderna, São Paulo; *Contemporary Works on Paper by 49 Brazilian Artists,* Nobé Gallery, New York; 1978 Galleria Saramenha, Rio de Janeiro (solo); L'Oggetto dell'Arte, Il Brasile nel '60, Fondazione Armando Alvares Penteado, São Paulo; 1977 Arte Attuale dell'America Latina, Instituto de Cultura Ispanica Madrid; 1976 Petite Galerie, Rio de Janeiro (solo); 1975 Galleria Arte Global, São Paulo (solo)

JOSÉ CASTRO LEÑERO

b. México, D.F., México, 1953

Studies: Escuela Nacional de Artes Plásticas, UNAM, México, D.F. **Exhibitions:** 1990 *Vida de Papel,* Galería a Negra, México, D.F. (solo); 1989 *Cruce de Caminos,* Galería Pecanins, México, D.F.; 1988 *Días Posteriores,* Galería Sloane Racotta, México, D.F. (solo); *One Place Four Spaces,* Scott Alan Gallery, New York; 1983 *Trayecto,* Museo de Arte Carrillo Gil, México, D.F. (solo); 1982 *Mexican Artists Books,* Franklin Furnace, New York

ELBA DAMAST

b. Island of Pedernales, Venezuela, 1944 (in New York since 1972)

Studies: School of Plastic Arts, Arturo Michelena, Valencia, Venezuela; Eloy Palacios School, Maturin, Venezuela. **Exhibitions:** 1990 Museum of Contemporary Hispanic Art, New York (solo); Galleri Malen, Landskrona, Sweden; *Lines of Vision,* Museum of Contemporary Art, Caracas; *China...June 4,* Institute for Contemporary Art, P.S. 1 Museum, Long Island City; 1988 Gallery 101, Malmo, Sweden (solo); 1988 Alexander Ernst Gallery, Washington, D.C. (solo). **Collections:** Museo de Arte Contemporáneo, Caracas; Housatonic Museum of Art, Bridgeport, Connecticut

JORGE DAMIANI

Uruguay, b. Genoa, Italy, 1931

Studies: Academie Brera, Milan. **Exhibitions:** 1989 XX Bienal de São Paulo; 1988 Galería Bruzzone, Montevideo (solo); *Arte Uruguayo Contemporáneo,* Moscow; 1982 Arte Contemporáneo en el Uruguay, République Federal de Alemania; 1978 Pintura Uruguaya, Instituto Paraguayo-Americano, Asunción, Paraguay; 1977 Gordon Gallery, Buenos Aires (solo); 1975 Instituto Italiano de Cultura, Montevideo

HELEN ESCOBEDO

b. México, 1928

Awards: 1991 John Simon Guggenheim Foundation. **Exhibitions:** 1990 3 *Naturalezas Muertas*, Galería de Arte, Centro Libanes, México, D.F. (solo); *Agua, Aguas Paraguas*, Galería Sloane Racotta, México, D.F. (solo); 1989 *Para Re-Inventar la Naturaleza*, Sala Ollin Yoliztli, México, D.F. (solo); "Seaview," (obra monumental), Arlington House, London; 1988 *Lluvia de Granos*, Festival Cervantino, León (solo); "Columnas Liquidas" (obra monumental), Hamburg, Germany; 1986 *El jardin de la cosecha*, Museu de Arte Contemporáneo, Morelia, Michoacán (solo); Llewellyn Gallery, New Orleans (solo)

LUIZ ERNESTO

b. Rio de Janeiro, Brazil, 1955

Studies: School of Visual Arts, Rio de Janeiro; Catholic University of Petrópolis, Rio de Janeiro. **Exhibitions:** 1990 Anna Maria Niemeyer Gallery, Rio de Janeiro (solo): 1989 *Mestre á Mostra*, School of Visual Arts, Rio de Janeiro, 1988 Suzanna Sassoon Gallery, São Paulo (solo); 1987 Montesanti Gallery, Rio de Janeiro; 1986 *Território Ocupado*, installation, School of Visual Art, Rio de Janeiro; 9th National Art Show, Belo Horizonte; *Na pointa do lápis*, UFF Gallery, Niterói, Rio de Janeiro

MALU FATORELLI

b. Rio de Janeiro, Brazil, 1956

Studies: Federal University of Rio de Janeiro (architecture); Escola de Artes Visuais, Rio de Janeiro; Graphic School of Venize, Italy. **Exhibitions:** 1990 Sprengel Museum, Hannover, Germany (solo); *12 Caminhos*, Galeria Montessanti, Rio de Janeiro; *O Rosto e a Obra*, Galeria do Ibeu, Rio de Janeiro; 1989 Centro Empresarial Rio, Rio de Janeiro (solo): VII Salão de Arte Contemporãnea de São Paulo; Prêmio International de Grafica do Forni, Venize Italy; 1988 Centro Internationale Della Grafica Di Venezia (solo): Casa da Gravura, Fundação Cultural de Curitiba

BEATRIZ GONZÁLEZ

b. Bucaramanga, Colombia, 1938

Studies: Universidad de los Andes de Bogotá; Academia van Beeldende Kunsten, Rotterdam. **Exhibitions:** 1990 XXXIII Salón anual de artistas colombianos, Bogotá; Cámara de Comercio, Cali; 1988 Galería Garcés Velásquez, Bogotá (solo); 1987-88 *Art of the Fantastic: Latin America, 1920-1987*, Museum of Art, Indianapolis; 1986 Círculo de Periodistas, Bogotá (solo); 1984 Museo de Arte Moderno de Bogotá (retrospective)

ENRIQUE GRAU

b. Cartagena, Colombia, 1920

Studies: Art Students League, New York; Accademia di San Marco, Florence. **Exhibitions:** 1988 *The Latin American Spirit: Art and Artists in the United States, 1920-1970*, The Bronx Museum; 1985 *Five Colombian Masters*, Museum of Modern Art of Latin America, Washington, D.C.; 1983 World Print Council, San Francisco; Sexta Bienial del Grabado Latinoaméricana, Instituto de Cultura Puertorriqueña, San Juan; *Enrique Grau, Tridimensionales*, Museo de Arte Moderno, Cartagena (solo); 1981 IV Bienal de Arte de Medellín; 1980 *Homenaje a Grau*, Galería El Marqués, Cartagena; 1964 Carnegie International, Pittsburgh; 1961 VII Bienal de São Paulo; 1960 Guggenheim International, New York. **Collections:** Museum of Modern Art of Latin America, Washington, D.C.

CARMELA GROSS

b. São Paulo, Brazil, 1946

Studies: Escola de Comunicações e Artes da Universidade de São Paulo; Fundação Armando Alvares Penteado, São Paulo. **Exhibitions:** 1989 *Objetos Bestas*, Galeria Espaço Capital, Brasília (solo); XX Bienal Internacional de São Paulo; *9 Mulheres*, Galeria Milan, São Paulo, *Panorama da Arte Brasileira*, Museu de Arte Moderna, São Paulo; 1988 *Pintura/Objeto*, Museu de Arte do Rio Grande do Sul (solo); Pintura, Galeria São Paulo (solo); 1986 *Quasares*, Espaço Latino-Americano, Paris (solo): *Pintura*, Galeria Luiza Strina, São Paulo (solo); 1984 *Pinturas, Montagens, Cartazes*, Galeria Luiza Strina, São Paulo (solo); Galeria Zona, Florence

RAFAEL HASTINGS

b. Lima, Perú, 1945

Studies: Academie des Beaux Arts, Louvain; Academie des Beaux Arts, Brussels; Royal College of Art, London. **Exhibitions:** 1990 Latin American Invitational, Virginia Miller Galleries, Coral Gables; 1989 La Galería, Quito, Ecuador (solo); La Galería, Lima (solo); The Levin Collection, Chicago; 1988 Luciano Inga-Pins-Milano, Milan; *Dibujos de Taller*, Galería de Barranco, Lima; 1987 G.I.R. Gallery, Tokyo (solo); Galerie Internationale, Geneva (solo); Encuentro de Arte, Galería Praxis, Lima, Santiago, Buenos Aires; 1986 Hopkins Gallery, Atlanta (solo); Drawings, The Contemporary Masters, Texas Academy of Art; 1985 Fred Jahn Gallery, Munich (solo)

PATRICIA ISRAEL

b. Temuco, Chile, 1939

Studies: School of Fine Arts, University of Chile. **Exhibitions:** 1989 Galería Epoca, Santiago (solo); 1988 Arte-Industria, Museo Bellas Artes, Santiago; 10 artistas chilenos en el Museo de Arte Moderno La Tertulia, Cali; 1987 Galería Carmen Waugh, Santiago (solo); 1986 Biennal de la Habana, Cuba. **Collections:** Museo Nacional de Bellas Artes, Santiago; Museo Fundación Wifredo Lam, Havana; Museo de la Solidaridad, Salvador Allende, Chile

HAYDEE LANDING

b. Santurce, Puerto Rico, 1956

Studies: Universidad de Puerto Rico; Escuela Nacional de Artes Plásticas, UNAM, México. **Exhibitions:** 1989 XVIII Bienal Internacional de Artes Gráficas, Llubljana, Yugoslavia; *Corte, Forma y Color*, Galería del Hotel Normandie, San Juan; *Arte para la vida*, Museo de Arte e Historia de San Juan; *Arte Actual*, Museo de Arte e Historia de San Juan; *Encuentro*, Galería Costa Azul, San Juan; 1988 Liga de Estudiantes de Arte, San Juan en homenaje a la Bienal del Grabado Latinoaméricano (solo); 1988 *Art Under the Sun*, Galería Wilkow-Goldfeder, New York; Segundo Congreso de Creación Femenina en el mundo Hispánico, Mayagüez, Puerto Rico; 1986 Palacio de Gobierno de Tlaxcala, México (solo)

ANTONIO MARTORELL

b. Santurce, Puerto Rico, 1939

Studies: painting and drawing, Madrid; graphic apprentice at Taller de Artes Gráficas del Instituto de Cultura Puertorriqueña. Founded Taller Alacrán (Scorpion Workshop), a print collective, San Juan, 1968. **Exhibitions:** 1988 *The Latin American Spirit: Art and Artists in the United States, 1920-1970*, The Bronx Museum of the Arts; 1986 *Antonio Martorell, Obra Gráfica 1963-86*, Instituto de Cultura Puertorriqueña, San Juan (solo); 1970 Galerie San Juan; 1968

Galería Colibrí, San Juan (solo); 1965 Randolph Gallery, Houston; 1964 New York Art Director's Club (solo). **Collections:** Art Institute of Chicago; El Museo del Barrio, New York; The Museum of Modern Art, New York; Museo de Arte de Ponce, Puerto Rico

LUCÍA MAYA

México, b. Santa Catalina, California, 1953

Studies: Escuela de Artes Plásticas de la Universidad de Guadalajara; Instituto Allende, San Miguel Allende; Academia de San Fernando de Bellas Artes, Madrid. **Exhibitions:** 1990 *El Umbral de las Transfiguraciones*, Instituto Cultural Cabanas, Guadalajara and Centro Cultural, Tijuana (solo), *The Blush of Darkness*, Galéria Marcella Halpert, New York (solo) and 1989 Robert Dana Gallery, San Francisco; 1987 *Latin American Drawings*, The Art Institute of Chicago. **Collections:** Museo Monterrey, Instituto de Cultura Puertorriqueña, San Juan

MANUEL MENDIVE

b. Havana, Cuba, 1944

Studies: San Alejandro Academy, Havana. **Exhibitions:** 1990 25th International Salon of Art, Zagabria, Yugoslavia; Cuban Cultural Center, Rome; 1989 *Art in Latin America*, The Hayward Gallery, London; Centro Cultural, Madrid; Galerie Nesle, Paris (solo); Philippine Cultural Center, Manila (solo); Galería Roberto Diago, Havana (solo); 1988 represented Cuba at Venice Biennale; ARTEXPO Budapest; 1987 *Cuba, Magic Realism*, Pentonville Gallery, London

JOSE NEMER

b. Ouro Preto, Brazil, 1945

Studies: Universidade Federal de Minas Gerais; Sorbonne University, Paris. **Awards:** 1982 Brazilian Drawing Prize, Museum of Contemporary Art, Curitiba, Paraná; 1981 Drawing Prize MBR, Culture Affairs Department, Minas Gerais State; 1980 Drawing Prize, Museum of Modern Art of São Paulo; 1974 Drawing Prize, Brazilian Art Global Exhibition; Drawing Prize, Contemporary Art Museum, Paraná. Presently chairs the Art Research Center of Minas Gerais Federal University (UFMG)

GUILLERMO NUÑEZ

b. Santiago, Chile, 1930

Studies: in Santiago, Paris, Prague, and New York. **Exhibitions:** 1987 *Suite de Boësses*, Galerie d'Hotel de Ville, Bobigny, France, and Galería de Arte Actual, Santiago, Chile (solo); 1986 Galerie de l'Aeroport d'Orly, France; Massachusetts College Art Gallery, Boston (solo); *¿Qué hoy en el fondo de tus ojos?* Casa de la Cultura de la Legua, Santiago; 1983 *Kreig und Frieden*, Gesellschaft fur Actuelle Kunst, Bremen, Germany; Volkhaus, Zurich (solo). **Collections:** Museum of Modern Art, New York; Museo Nacional de Bellas Artes, Santiago

LILIANA PORTER

b. Buenos Aires, Argentina 1941 (in New York since 1964)

Studies: Ibero-American University, México, D.F.; Escuela Nacional de Bellas Artes, Buenos Aires. **Exhibitions:** 1990 The World Gallery, Syracuse University (solo); 1989 *Ideas and Images from Argentina*, Museum of Modern Art of Latin America, Washington, D.C.; 1988 The Space, Boston (solo); Casa de las Américas, Havana (solo); Galleria Krysztofory, Cracow (solo); 1986 Gran Prix, Latin American Graphic Arts Biennial, Museum of Contemporary Hispanic Art, New York. **Collections:** Museum of Modern Art, New York; Museo de Bellas Artes, Buenos Aires

FRANCISCO DE LA PUENTE

b. Santiago, Chile, 1953

Exhibitions: 1990 Museo de Arte Moderno La Tertulia, Cali (solo); XXII Festival
Internacional de la Pintura CAGNES, France; 1989 Galería Epoca, Santiago (solo); IX Bienal
Internacional de Arte, Valparaíso; 3er Encuentro Arte Industria, Museo Nacional de Bellas
Artes, Chile; 1988 *10 Painters*, Security Pacific Bank, Los Angeles; Universidad de Magallanes,
Punta Arenas, Chile; 1987 VI Bienal Arquitectura Museu Nacional Bellas Artes, Santiago.
Collections: Museo Nacional de Bellas Arte, Santiago; Museo Maldonado Uruguay; Chase
Manhattan Bank, New York

SILVIA RIVAS

b. Buenos Aires, Argentina, 1957

Studies: Escuela Nacional de Bellas Artes "Prilidiano Pueyrredon." **Exhibitions:** 1990 Salón
Manuel Belgrano, Museo Sivori, Centro Cultural Ciudad de Buenos Aires; *Artistas de Buenos
Aires*, CAYC, Buenos Aires; Museo de Arte Moderno México; Museo de La Tertulia, Cali;
Museo de Arte de San Pablo, Brazil; Pinturas, TEMA Galería de Arte (solo); 1989 *Artistas
Argentinos*, The Bronx Museum of the Arts; Premio Manliba, Centro Cultural Ciudad
de Buenos Aires; Pinturas, TEMA Galería de Arte; 1987 Premio Manliba, Centro Cultural
Malvinas, Bienal de Arquitectura

JOSÉ MIGUEL ROJAS

b. San José, Costa Rica, 1959

Studies: Universidad de Costa Rica. **Exhibitions:** 1989 Museu de Arte Costarricense, San
José; Galería Nacional de Arte Contemporáneo, San José; Instituto Anglo Costarricense de
Cultura, San José; 1988 Teatro Nacional de Costa Rica, San José (solo); Museum of Modern
Art of Latin America, Washington, D.C.; 1987 Escuela de Artes Plásticas, Universidad de
Costa Rica (solo); 1986 II Bienal de la Habana, Cuba; Museos Banco Central de Costa Rica,
San José (solo); 1985 Instituto Tecnológico de Costa Rica; Galería Nacional de Arte
Contemporáneo, San José

MIGUEL ANGEL ROJAS

b. Bogotá, Colombia, 1946

Studies: Universidad Javeriana, Bogotá (architecture); Universidad Nacional, Bogotá
(fine art). **Exhibitions:** 1988 Biblioteca Luis Angel Arango, Bogotá; 1987 Museo de Arte
Universidad Nacional, Bogotá; The Australian Centre for Photography, Paddington, Australia;
Consulate General of Colombia, Miami; 1986 II Bienal de la Habana, Cuba; Mall Galleries,
London; 1985 Museo de Arte Moderno, Bogotá. **Collections:** Museum of Modern Art,
New York; Museo de Arte Moderno de Bogotá; Casa de las Américas, Havana

ISABEL RUIZ

b. Guatemala, 1945

Studies: Universidad Popular de Guatemala; Escuela Nacional de Artes Plásticas.
1987 co-founder of alternative space, Galería Imaginaria, Antigua Guatemala. **Exhibitions:**
(solo) Guatemala; México; El Salvador; (group) New York; Austin, Texas, (graphics
biennials) Taipei; San Juan, Puerto Rico; Valparaíso; Curitiba, Brazil; Tegucigalpa,
Honduras; New York

JORGE TACLA

b. Santiago, Chile, 1958 (in New York since 1981)

Studies: Universidad de Chile, Santiago. **Exhibitions:** 1990 Nohra Haime Gallery, New York (solo); National Museum of Contemporary Art, Seoul, South Korea; *China...June 4*, BlumHelman Warehouse, New York and Hong Kong Art Center; *The Decade Show*, Museum of Contemporary Hispanic Art, New Museum, and Studio Museum in Harlem, New York; 1989 Seibu Fine Arts Gallery, Tokyo (solo); 1988-89 *MIRA*, Los Angeles Municipal Art Gallery, Los Angeles (traveling exhibition). **Collections:** Archer M. Huntington Art Gallery, University of Texas at Austin

FRANCISCO TOLEDO

b. Juchitan, Oaxaca, México, 1940

Studies: Taller Libre de Grabado, México, D.F.; Stanley William Hayter Workshop, Paris; self-taught painter. **Exhibitions:** 1990 Nohra Haime Gallery, New York (solo); *Mexican Painting 1950-1980*, IBM Gallery, New York; 1989 *Art in Latin America*, The Hayward Gallery, London; 1988 Galería Lopez Quiroga, México, D.F. (solo); The Mexican Fine Arts Center Museum, Chicago (solo); 1987-88 *Imagen de Mexico*, Schirn Kunsthalle, Frankfurt; 1986-87 *Francisco Toledo Zoologia Fantastica* (solo traveling exhibition). **Collections:** Metropolitan Museum of Art, New York; Tate Gallery, London; Museum of Modern Art, New York; Museo de Arte Moderno, México

REGINA VATER

b. Rio de Janeiro, Brazil, 1943

Studies: Universidad Federal do Rio Janeiro. **Exhibitions:** 1990 *The Revered Earth*, The Contemporary Arts Museum, Houston; *Transcontinental*, Ikon Gallery, Birmingham and Manchester, England; 1989 *Here and There, Part 2*, P.S. 1 Museum Clocktower Gallery, New York; Women's Studio Workshop, Rosendale, New York (solo); 1988 Museum of Contemporary Art, University of São Paulo (solo); 1985 University of Texas, Archer M. Huntington Art Gallery, Austin (solo); 1981 Eugenia Cucalon Gallery, New York (solo); 1978 C-Space Gallery, New York (solo)

OSWALDO VIGAS

b. Valencia, Carabobo, Venezuela, 1926

Studies: Ecole de Beaux Arts, Paris (printmaking); Stanley William Hayter Workshop, Paris. **Exhibitions:** 1990 Museum of Contemporary Art Sofia Imber, Caracas, (retrospective); 1986 Museum of Contemporary Hispanic Art, New York; 1983 Consulate of Venezuela, New York; 1980 Navy Pier, Chicago; 1976 Xerox Corporation; Rochester, New York; 1973 World Print Competition, San Francisco; 1963 Adams Morgan Gallery, Washington, D.C.; 1959 Dallas Museum of Fine Arts; 1959 The Art Institute of Chicago

CARLOS ZERPA

b. Valencia, Venezuela, 1950

Studies: Politecnic of Design Institute, Milan; OEA-IDEC, Bogotá; Art Students League, New York. **Exhibitions:** 1988 Fco. Narváez Museum, Porlamar, Venezuela (solo); Americas Society Gallery New York; 1987 INTAR Gallery, New York (solo); Mendoza Gallery, Caracas (solo); 1986 Hamburg Art Festival, West Germany; III National Sculpture Biennial, Fco. Narváez Museum, Porlamar, Venezuela; 1985 Contemporary Art Museum, Caracas. **Collections:** The Bronx Museum, New York; Guilio Rodino Museum, Naples; Contemporary Art Museum, Caracas; Franklin Furnace, New York

Latin American Drawings Today

All works lent by the artist unless otherwise indicated.

Height precedes width.

• indicates catalogue illustration.

Rodolfo Abularach
Guatemala, b. 1933
Madre •
1990, color pencil, 23" x 30"
Familia
1990, color pencil, 23" x 30"

Ramón Alejandro
Cuba, b. 1943
Fatum (Destiny) •
1990, pierre noire
43 1/4" x 29 1/2"
In principio (In the Beginning)
1990, pierre noire
29 1/2" x 43 1/4"
La conquista (The Conquest) •
1990, pierre noire
43 1/4" x 29 1/2"

Fernando Allievi
Argentina, b. 1954
El enfermo •
1986, ink and gouache
58 1/2" x 52 1/2"
Courtesy of Bonino Gallery, New York
Sin título
1989, ink and gouache
31 1/2" x 36"
Courtesy of Bonino Gallery, New York
El atico de Misram •
1989, ink and gouache
46" x 30 3/4"
Courtesy of Bonino Gallery, New York

Jorge Alvaro
Argentina, b. 1949
Interior
1983, ink and gouache
40" x 28 1/2"
Courtesy of Bonino Gallery, New York
Contortionista •
1979, ink and gouache
40" x 28 1/2"
Courtesy of Bonino Gallery, New York
Winged Woman II - Riposo
1983, ink and gouache
40" x 28 1/2"
Courtesy of Bonino Gallery, New York

Antônio Henrique Amaral
Brazil, b. 1935
Forest,
1987, oil pastel, 11 3/4" x 18 1/8"
Flying Parts •
1985, oil pastel, 12 1/2" x 19"
Hearts and Fish •
1984, oil pastel, 12 1/4" x 16 1/16"

Félix Angel
Colombia, b. 1949
Figure
1990, pencil, wax crayon, and acrylic
40" x 32"
Untitled •
1990, pencil, wax crayon, and acrylic
32" x 40"
Untitled •
1990, pencil, wax crayon, and acrylic
32" x 40"

Humberto Aquino
Perú, b. 1947
Still Life with Goblet
1987, mixed media, 11 1/2" x 11 5/8"
Courtesy of Odon Wagner Gallery,
Toronto
Portrait of a Conquestador •
1990, mixed media, 15" x 13"
Courtesy of Mr. and Mrs. Odon Wagner
Artist at Work
1988, mixed media, 18" x 20 1/2"
Courtesy of Odon Wagner Gallery,
Toronto

Tancredo de Araujo
Brazil, b. 1942
Amazonia I
1990, mixed media
28 3/4" x 40 1/4"
Amazonia II
1990, mixed media
28 3/4" x 40 1/4"
Amazonia III
1990, mixed media
28 3/4" x 40 1/4"

Ever Astudillo
Colombia, b. 1948
Ho-Ménage à Trois I
1988, pencil, 55" x 47"
Ho-Ménage à Trois II •
1988, pencil, 55" x 47 1/8"
Sábado •
1986, pencil, 54 7/8" x 44"

Alvaro Barrios
Colombia, b. 1945
*Variaciónes sobre un tema de Hippolyte —
Jean Flandrin*
1989-90, ink, color pencil, and collage
17 3/4" x 27 1/2"
El artista y su musa
1989, ink, watercolor, and collage
19 7/16" x 29"
*Jupiter transforma en estrellas a las hijas
de Atlas* •
1989, ink and watercolor, 21" x 28 3/4"

Arnold Belkin
México, b. 1930
#1 Serie Lucio Cabañas
1985, mixed media
94 1/2" x 51 1/4"
#2 Serie Lucio Cabañas •
1985, mixed media
94 1/2" x 51 1/4"
#3 Serie Lucio Cabañas
1986, mixed media
94 1/2" x 51 1/4"

Luis Benedit
Argentina, b. 1937
El lazo como instrumento de la conquista •
1985, watercolor
43" x 53 1/2"
Courtesy of CDS Gallery, New York
T. A. segundo version •
1990, pencil
54 1/2" x 76 3/4"
Courtesy of Galería de Arte
Ruth Bencazar, Buenos Aires
Del cuaderno de religión de Julian A
1989, sepia and graphite
60" x 72"
Courtesy of Galería de Arte
Ruth Bencazar, Buenos Aires
Del cuaderno de religión de Julian B
1989, graphite, 53 3/4" x 67 3/4"
Courtesy of Galería de Arte
Ruth Bencazar, Buenos Aires

Lena Bergstein
Brazil, b. 1946
Part and Whole A
1989, transfer drawing
and watercolor, 24" x 28 3/4"
Part and Whole B
1989, transfer drawing
and watercolor, 24" x 28 3/4"
Part and Whole C
1989, transfer drawing
and watercolor, 24" x 28 3/4"

Guillermo Bert
Chile, b. 1957
Lady and the Pig •
1985, pastel, 72" x 38"
Courtesy of Adam J. Merims,
Los Angeles
Crucifixion
1985, pastel, 26 1/4" x 32 1/8"
Private Collection, Los Angeles
Beyond Privacy
1985, pastel, 72" x 38"

Norma Bessouet
Argentina
Anna
1989, pastel, pencil, and gouache
30" x 23"
The One Rose
1980, pencil and color pencil
28 3/4" x 20"
The Meaning of His Absence •
1985, pencil
32" x 20"

Herman Braun-Vega
Peru, b. 1933
¡Hasta que no les quede una pluma!
(Ya van desplumados - Goya) •
1990, pencil and acrylic
47" x 39 3/4"
Retrato de Wifredo Lam pintor
1982, pencil and acrylic
47 1/4" x 33 1/2"
El sembrador •
1981, pencil and acrylic
58 3/4" x 34 1/4"

Claudio Bravo
Chile, b. 1936
The Guardian
1977, ink and conte, 27" x 20"
Courtesy of
The Forbes Magazine Collection,
New York
Seated Male from Back •
1982, pencil, 29" x 24 1/2"
Courtesy of
The Forbes Magazine Collection,
New York

Luis Caballero
Colombia, b. 1943
Untitled •
1988, colored pigments
20" x 26"
Courtesy of Galerie Albert Loeb, Paris
Untitled •
1988, colored pigments
20" x 26"
Courtesy of Galerie Albert Loeb, Paris
Untitled
1988, colored pigments
20" x 26"
Courtesy of Galerie Albert Loeb, Paris

Rimer Cardillo
Uruguay, b. 1944
Memorial I, Triptych •
1988, graphite, pencil, and collage
30" x 22"

Memorial II, Altar
1988, graphite, pastel, and collage
30" x 22"
Memorial III, Reliquary
1988, graphite, 30" x 22"

Alicia Carletti
Argentina, b. 1946
Rincón secreto
1983, watercolor, 40 1/4" x 29"
Juegos en el jardin •
1983, watercolor, 40 1/4" x 29"

Maria do Carmo Secco
Brazil, b. 1933
Untitled
1986, ink, watercolor, color pencil,
and pastel, 27 1/4" x 39 1/2"
Courtesy of Gilberto Chateaubriand
Untitled
1986, ink, watercolor, color pencil,
and pastel, 27 1/4" x 39 1/2"
Courtesy of Gilberto Chateaubriand
Untitled
1986, ink, watercolor, color pencil,
and pastel, 27 1/4" x 39 1/2"
Courtesy of Gilberto Chateaubriand

José Castro Leñero
México, b. 1953
Ciudad al paso
1990, ink, 31 1/2" x 47 1/4"
Blues de la calle (9) nueve •
1990, ink, 31 1/2" x 47 1/4"
Travesia •
1990, ink, 31 1/2" x 47 1/4"

Elba Damast
Venezuela, b. 1944
Pregnant by Her Own Reality •
1990, mixed media, 84" x 60"
The Man Came and Stayed There •
1990, mixed media, 84" x 60"

Jorge Damiani
Uruguay, b. 1931
Vision II
1988, acrylic and graphite
27 1/4" x 35 1/2"
Vision III •
1988, acrylic and graphite
35 1/2" x 27 1/4"
Vision XI
1989, acrylic and graphite
27 1/4" x 35 1/2"

Luiz Ernesto
Brazil, b. 1955
TV
1988, graphite, 39 1/2" x 28"
Chicken
1988, graphite, 28" x 39 1/2"
Vacuum Cleaner
1988, graphite, 28" x 39 1/2"

Helen Escobedo
Mexico, b. 1928
Mares •
1989, crayon and charcoal
16 1/4" x 20 1/4"
Courtesy of Marion E. Greene,
St. Helena, California
Mares •
1989, crayon and charcoal
16 1/4" x 20 1/4"
Courtesy of Marion E. Greene,
St. Helena, California

Malu Fatorelli
Brazil, b. 1956
German Hart
1989, gouache, graphite, pastel,
and ink, 27 1/2" x 35 1/2"
Só assim
1990, gouache, graphite, pastel,
and ink, 27 1/2" x 35 1/2"
Feitos um para o outro
1989, gouache, graphite, pastel,
and ink, 27 1/2" x 35 1/2"

Beatriz González
Colombia, b. 1938
Palaciegos •
1990, charcoal and pastel
51 1/4" x 34 3/4"
Silencio mudo
1990, charcoal and pastel
27 1/4" x 50 1/2"
*Sr. Presidente que honor estar con UD.
en este momento histórico* •
1986, pastel and charcoal
59 1/4" x 59 1/4"

Enrique Grau
Colombia, b. 1920
La ofrenda •
1990, charcoal and pastel
31 1/2" x 48"
El ajustador rosado •
1990, charcoal and pastel
48" x 31 1/2"
El espejo
1990, charcoal, 31 1/2" x 48"

Carmela Gross
Brazil, b. 1946
Stones
1990, graffiti and resin
59 1/2" x 39 1/2"
Stones
1990, graffiti and resin
59 1/2" x 39 1/2"
Stones
1990, graffiti and resin
59 1/2" x 39 1/2"

Rafael Hastings
Perú, b. 1949
Order
1990, conte, charcoal, and chalk
50 3/4" x 39 3/4"
Courtesy of the artist and
Virginia Miller Galleries,
Coral Gables, Florida
Disorder •
1984, conte, pencil, and charcoal
24 1/2" x 35 3/4"
Courtesy of the artist and
Virginia Miller Galleries
Coral Gables, Florida
Disorder
1984, conte, pencil, and charcoal
24 1/2" x 35 3/4"
Courtesy of the artist and
Virginia Miller Galleries,
Coral Gables, Florida

Patricia Israel
Chile, b. 1939
El hombre que lloraba
1989, pastel and charcoal
30 1/2" x 39 1/2"
América de cuerpo pintada •
1989, pastel, crayon, and charcoal
30 1/2" x 41 1/2"
Por los dios del fin del mundo •
1990, pastel, crayon, charcoal,
and pencil, 23 1/4" x 35"

Haydee Landing
Puerto Rico, b. 1956
Ciudad olvidada I •
1990, charcoal, crayon,
and graphite, 32" x 40"
Ciudad olvidada II
1990, charcoal, crayon,
and graphite, 32" x 40"
Bosque interior II
1990, charcoal, crayon,
and graphite, 32" x 40"

Antonio Martorell
Puerto Rico, b. 1939
Mango Tree •
1990, charcoal, 38" x 50"
Tree Stump •
1990, charcoal, 50" x 38"
Tree Trunk
1990, charcoal, 50" x 38"

Lucía Maya
México, b. 1953
Viento de pesadilla
1989, pencil, 59" x 78 3/4"
Courtesy of Ricardo Orozco
Madre del olvido •
1987, pencil, 57 1/4" x 37 1/2"
Courtesy of Ricardo Orozco
Crisálida
1988, pencil, 27" x 38 1/2"
Courtesy of the artist
and Galería Carmen Cuenca,
Tijuana

Manuel Mendive
Cuba, b. 1944
Verde lino •
1989, pastel, 27 3/4" x 37 1/4"
Courtesy of Carin Arte, Vicenza
Senza título
1989, pastel, 20 1/4" x 25 3/4"
Courtesy of Carin Arte, Vicenza
Gallina de cabeza rota •
1989, pastel, 25 3/4" x 40 1/4"
Courtesy of Carin Arte, Vicenza

José Alberto Nemer
Brazil, b. 1945
Sem título
1987, pastel, 25 3/4" x 19 3/4"
O homem que perdeu sua casa
1987, pastel, 25 3/4" x 19 3/4"
Sem título
1987-88, pastel, 25 3/4" x 19 3/4"

Guillermo Nuñez
Chile, b. 1930
De la serie "le dejeuner sur l'herbe"
1990, ink and color pencil
25 3/4" x 19 3/4"
De la serie "le dejeuner sur l'herbe" •
1990, oil stick and color pencil
25 3/4" x 19 3/4"
De la serie "suite de Boësses" •
1985, ink, color pencil, and acrylic
19 3/4" x 25 3/4"

Liliana Porter
Argentina, b. 1941
White Reconstruction II
1990, acrylic, pencil,
collage, and assemblage, 29" x 30"
The Other One •
1990, pencil, charcoal,
ink, and collage, 32 1/2" x 24 1/2"

Francisco de la Puente
Chile, b. 1953
Untitled
1988, mixed media, 42 1/2" x 59"
Untitled •
1988, mixed media, 27 1/4" x 39 1/2"
Untitled
1988, mixed media, 27 1/4" x 39 1/2"

Silvia Rivas
Argentina, b. 1957
Realidades superpuestas
1990, ink marker, 25" x 17 3/4"
Fuera de contacto
1990, ink marker, 25" x 17 3/4"
Un infinito en otro •
1990, ink marker, 25" x 17 3/4"

José Miguel Rojas
Costa Rica, b. 1959
Pensando en...
1989, ink, 14" x 10 7/8"
Conversando con... •
1989, ink, 14" x 10 7/8"
Esperando a... •
1989, ink, 14" x 10 7/8"

Miguel Angel Rojas
Colombia, b. 1946
Autorretrato en camino •
1977, graphite, 12" x 9"

Isabel Ruiz
Guatemala, b. 1945
Historia sitiada •
1990, watercolor, 39 1/2" x 55 1/8"
Desaguadero I •
1989, watercolor and mixed media,
parts 1 and 2: 55 1/8" x 78 3/4"
parts 3 and 4: 55 1/8" x 78 3/4"
Sahumerio I
1988, watercolor, 55 1/8" x 39 1/4"

Jorge Tacla
Chile, b. 1958
Ése arte filo •
1988, watercolor, 27 5/8" x 19 7/8"
Courtesy of Nohra Haime Gallery,
New York

B=B •
1988, watercolor
27 5/8" x 19 7/8"
Private Collection, México, D.F.
Intercambio cultural
1988, watercolor
27 5/8" x 19 7/8"
Courtesy of Nohra Haime Gallery,
New York

Francisco Toledo
México, b. 1940
Figura verde
n.d., gouache and watercolor
18" x 17 1/2"
Courtesy of Marion E. Greene
St. Helena, California
Locusts
1972, ink
13" x 16"
Courtesy of Marion E. Greene
St. Helena, California
La máquina de coser de Dona Flor •
1987, gouache
33" x 24"
Courtesy of Marion E. Greene
St. Helena, California

Regina Vater
Brazil, b. 1943
Anakonda •
1989, acrylic, 38" x 50"
Nana
1989, acrylic, 38" x 50"
Dead Cargo •
1989, acrylic, 38" x 50"

Oswaldo Vigas
Venezuela, b. 1926
Animal •
1978, charcoal and sanguine
30" x 22 1/2"
Personaje mítico
1977, charcoal
30" x 22 1/2"
Cabeza •
1983, ink and casein
22 1/2" x 14 1/4"

Carlos Zerpa
Venezuela, b. 1950
Pop-Top •
1984, acrylic, 39 1/2" x 27 3/4"
De visita en América
1988, acrylic, 39 1/2" x 27 3/4"
Personaje •
1985, acrylic and ink
39 1/2" x 27 3/4"

BIBLIOGRAPHY

Latin American Drawings Today

Arden Gallery. *Norma Bessouet, Selvaggia and Uccello.* Boston: 1989

Art of the Fantastic, Latin America, 1920-1987. Indianapolis: Indianapolis Museum of Art, 1987

Art in Latin America, The Modern Era, 1820-1980. London: The Hayward Gallery, 1989

Ever Astudillo. Cali: Publicaciones Muro, 1989

Caballero, German Rubiano. *Enrique Grau.* Bogotá: Centro Colombo Américano, 1983

Carin Arte. *Mendive.* Vicenza: 1990

Centro Armitano Arte. *Oswaldo Vigas, Ceremoniales.* Caracas, 1989

Fuera de Cuba/Outside Cuba, Contemporary Cuban Visual Artists. New Brunswick: Office of Hispanic Arts, Mason Gross School of the Arts, Rutgers, The State University of New Jersey, and Miami: The Research Institute for Cuban Studies, University of Miami, 1988

Galerie Albert Loeb. *Caballero.* Paris: 1985

Galerie Jacques Desbriere. *Ramón Alejandro.* Paris: 1971

Galería de Arte Contemporáneo. *José Miguel Rojas, Imagenes del Poder.* San José, Costa Rica: 1989

Galería Plástica 3. *Guillermo Nuñez, Mirando a Itaca.* Santiago: 1990

Galería Sen. *Carlos Zerpa, Pinturas.* Madrid: 1990

Glusberg, Jorge. *Art in Argentina del Pop-Art a la Nueva Imagen.* Buenos Aires: Ediciones de Arte Gaglianone, 1985

Goldman, Shifra M. *Contemporary Mexican Painting in a Time of Change.* Austin: University of Texas Press, 1981

Ideas and Images from Argentina. New York: The Bronx Museum of the Arts, 1990

Instituto Cultural Cabanas. *Lucía Maya, Umbral de las Transformaciones.* Guadalajara, 1990

Instituto Nacional de Bellas Artes. *Arnold Belkin, 33 Años de Produccion Artistica.* Mexico, D.F.: 1989

INTAR Gallery. *Rimer Cardillo.* New York: 1989

Landskrona Konsthall. *Elba Damast, New York.* Landskrona, Sweden: 1989

Latin American Artists in New York Since 1970. Austin: Archer M. Huntington Art Gallery, 1987

Latin American Drawing. Chicago: The Art Institute of Chicago, 1987

Latin American Drawings from the Barbara Duncan Collection. Austin: Archer M. Huntington Art Gallery, 1988

The Latin American Spirit: Art and Artists in the United States, 1920-1970. New York: The Bronx Museum of the Arts and Harry N. Abrams, Inc., 1988

Messer, Thomas. *The Emergent Decade.* New York: The Solomon R. Guggenheim Museum, 1966

MIRA, The Canadian Club Hispanic Art Tour III. Farmington Hills: Hiram Walker Inc., 1988

Moss Gallery. *Colombian Figurative.* San Francisco: 1990

Musée Henri Boez. *Braun Vega Retrospective 1950-1989.* Maubeuge: 1989

Museo de Arte e Historia de San Juan. *Félix Angel, Obra Selecta 1977-1987.* San Juan: 1988

Museo de Arte Moderno Bogotá. *Alvaro Barrios, Veinte Años entre el Sueño y la Idea.* Bogotá: 1986

Museo de Arte Moderno La Tertulia. *Francisco de la Puente.* Cali: 1990

Museu de Arte Moderna, São Paulo. *Antônio Henrique Amaral: Obra em Processo 1956-1986.* São Paulo: 1986

Museum of Modern Art of Latin America, Selections from the Permanent Collection. Washington, D.C.: Organization of American States, 1985

New Art from Puerto Rico. Springfield: Museum of Fine Arts, 1990

Nohra Haime Gallery. *Francisco Toledo.* New York: 1990

Nohra Haime Gallery. *Jorge Tacla, Cuaresma en Atacama.* New York: 1989

Schirn Kunsthalle. *Imagen de Mexico.* Frankfurt, 1987

Stofflet, Mary and Michael Crane, eds. *Correspondence Art: Sourcebook for the Network of International Postal Art Activity.* San Francisco: Contemporary Arts Press, 1984

Sullivan, Edward J. *Claudio Bravo.* New York: Rizzoli International Publications, Inc., 1985

World Gallery, Syracuse University. *Liliana Porter.* Syracuse: 1990